MODERN BRITISH ART
at Pallant House Gallery

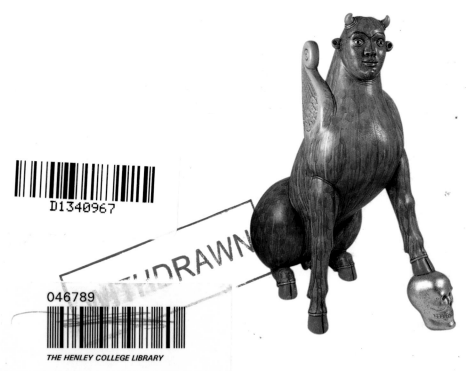

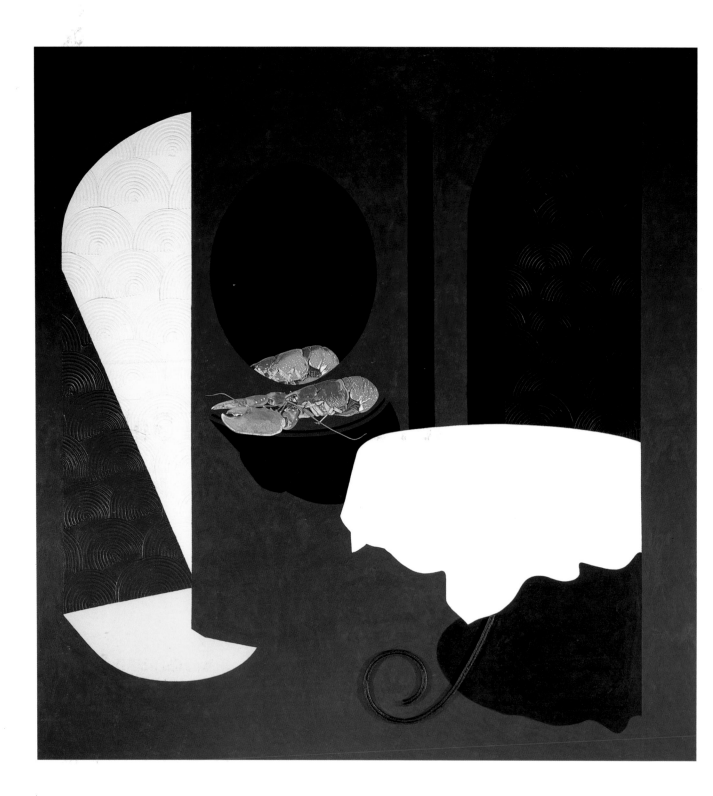

SCALA

MODERN BRITISH ART
at Pallant House Gallery

Stefan van Raay

Frances Guy

Simon Martin

Andrew Churchill

Publication details

© Scala Publishers
text © Pallant House Gallery
photography © Pallant House Gallery
2004/Stephen Head

All other photography:
7 © Henry Moore Foundation; 7 © The Trustees of the Edward James Foundation/Nicholas Sinclair; 10, 12 Long & Kentish Architects; 11, 129 Prudence Cumming Ass. Ltd.; 16 Pallant House Gallery/Apertures Professional Photography; 40 Pallant House Gallery/Beaver Photography; 65, 121 Tate Photography, Marcus Leith and Andrew Dunkley; 108, 111 Yale Centre for British Art/Richard Caspole; 119, 132, 133 Matthew Hollow; 125 Tate Photography, Rodney Tidnam; 127 Christopher Hurst; 135, 141 Susan Crowe; 136 Bob Cramp; 140 FXP Photographers; 142 Andy Goldsworthy

First published in 2004 by
Scala Publishers
Northburgh House
10 Northburgh Street
London EC1V 0AT

hardback ISBN 1-85759-366-9
paperback ISBN 1-85759-331-6

Edited by Esme West
Designed by Nigel Soper
Printed in Spain by Printek

Illustrations

Roger Reed, Chairman: foreword
Stefan van Raay, Director: chapter 1
Frances Guy, Curator: chapters 2, 5, 7, 8, 11
Simon Martin, Assistant Curator: chapters 3, 4, 6, 9, 10, 12
Andrew Churchill, Marketing and Commercial Manager: chapter 13

Page 1:
Dhruva Mistry (1957–)
Regarding Guardian 2 (1985)
Painted plaster sculpture, 110 cm high
Wilson Loan (2004)

Page 2:
Patrick Caulfield (1936–)
Reserved Table (2000)
Acrylic on board, 183 x 190 cm
Wilson Gift, through the National Art Collections Fund (2004)

Contents

Foreword

Just two decades ago Pallant House Gallery opened its doors to the public. Since then it has become one of the most important galleries for British modern art in the country. We are truly proud of what we have achieved: a new fully equipped gallery with facilities for exhibitions, events, learning and enjoyment will open in 2005. We are grateful to those who have staunchly supported the project over the years. A very special mention should go to David and Prue Hopkinson, Simon Sainsbury, Angus and Anne Hewat and Peter Headey. Mary Gordon Lennox, as Chairman of the Friends of Pallant House and of the Appeal, has most successfully pursued the fundraising effort with relentless energy and dedication. A substantial grant from the Heritage Lottery Fund was absolutely vital, and without the drive, enthusiasm and support of the Trustees, the Friends, the volunteers and, most of all, the Director, Stefan van Raay, and the staff, it would not have happened. The Chichester District Council, our main partner in the enterprise, decided to give a unique capital grant. Many others, mostly private donors, also gave us their financial support, and we want to pay tribute to their belief in the project.

The architects Long and Kentish in association with Professor Sir Colin St John Wilson have designed a new building, respecting the integrity of Pallant House. They responded with great sensitivity to the needs of the Gallery, which now also houses the Wilson Collection of twentieth-century modern and contemporary art, which came to the Gallery through the National Art Collections Fund.

In the arts the new gallery is an important addition to the cultural life of this part of the world: performing arts in the Chichester Festival Theatre; contemporary British sculpture at the Cass Sculpture Foundation; historic architecture and British and International art in Chichester Cathedral; and educational arts and crafts programmes and modern art collections at West Dean College and University College Chichester.

With regard to this book about the Gallery and its collections, thanks must go to Henry Channon, Jenny McKinley, Esme West and Tim Clarke of Scala Publishers and its designer Nigel Soper for their efforts in co-ordinating such a magnificent publication. It is a book of which we are justly proud. Thanks also to Stephen Head, whose photographs of the artworks have contributed so greatly to the quality of the book, and to Arts Council England South East which funded the photography as part of the Gallery's 'Building Bridges' project. The artists and artists' estates have been very generous in giving their permission for the images to be used. Anne Browning in the office of Colin St John Wilson and Associates has been most helpful in locating transparencies, and Professor Wilson himself has given the benefit of his particular knowledge of many of the artists and artworks. At Pallant House Gallery, Elaine Bentley, Emma Peradon, Pat Saunders, Marc Steene, David Wynn and Mary Gordon Lennox have all contributed practically and creatively to the realization of the project. Finally, much praise must go to the writing and editorial team of Frances Guy, Simon Martin and Andrew Churchill led by the Director, Stefan van Raay, without whose hard work and skill this publication would not have been possible.

We sincerely hope that many readers will enjoy this book and equally that many visitors enjoy what they see and experience in the Gallery for countless years to come.

Roger Reed
Chairman of the Pallant House Gallery Trust

Pallant House Gallery
The context

The dedication and perseverance of a publicly spirited few, supported by many who hoped this project would come to fruition, have created a new gallery of modern art. As is often the case, the birth of the Gallery was the result of a sadly missed opportunity. In the 1970s Chichester was offered the Edward James Collection of Surrealist art, one of the most important in the world. The eccentric Edward James (1907–84) was one of the greatest patrons of Surrealism. This collection would have made Chichester a centre of international art and an attraction for art lovers from all over Britain and abroad. After much prevarication by the District Council, the offer was withdrawn, the collection was auctioned off, and many icons of Surrealism now adorn the walls of major international collections. When Walter Hussey (1909–85), the Dean of Chichester from 1955 to 1977, offered his collection of British art to the city, a group of citizens were determined not to lose this second offer of a major collection. Like Edward James, Hussey was not only a collector but also, more significantly, a patron of the arts. As Vicar of St Matthews in Northampton he had

commissioned a Madonna and Child from Henry Moore and a Crucifixion from Graham Sutherland. Other artists like Marc Chagall, Geoffrey Clarke, Cecil Collins, John Piper and Ceri Richards received further commissions for Chichester Cathedral. Hussey's active promotion of contemporary art went beyond the visual. The group of works he commissioned by contemporary composers is equally impressive, including, among others, 'Rejoice in the Lamb' by Benjamin Britten, 'Chichester Mass' by William Albright and, most famously, the 'Chichester Psalms' by Leonard Bernstein. The experience of an evening of Hussey's music is truly moving.

It is no surprise that the man who commissioned these artists and became their friend also built up a fine private art collection. He spent his money wisely. Often the artists he commissioned gave him works or he negotiated more favourable prices with them. Hussey managed to get away with the gift of a fountain pen to Leonard Bernstein by way of a fee for the composition of the 'Chichester Psalms'. Hussey was proud of his collection. Some people still remember the unknown

René Magritte
(1898–1967)
Pleasure Principle (portrait of Edward James) (1937)

Oil on canvas
73 x 54 cm
Edward James
Foundation, West Dean

Henry Moore
(1898–1986)
Madonna and Child
(1943–44)

Hornton stone
150 cm high
Church of St Matthew,
Northampton

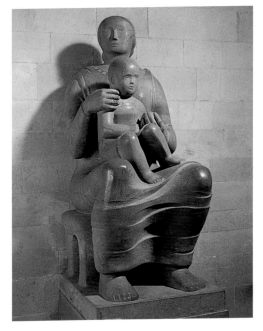

man who, after they had expressed an interest in the works of art in the Cathedral, would usher them into the Deanery to view his collection.

A notable contemporary of Hussey was the formidable Dr Elisabeth Murray (1909–98), Principal of Bishop Otter College, a teacher training college in Chichester. She was the granddaughter of Sir James Murray, the famous lexicographer, and became well known for the biography of her grandfather *Caught in the Web of Words*. With minimal means Betty Murray and Sheila McCririck, the Head of Art, built up an important collection of contemporary art for their students, which is still in the custody of what is now University College Chichester.

The Hussey and Bishop Otter collections are very complementary; while Hussey's collection is mainly representational, the Bishop Otter collection includes British abstract painters like Terry Frost, William Gear, Peter Lanyon and the eclectic Stanley Spencer.

When, in 1967 and again in 1974, Hussey expressed his wish to leave the collection to Chichester, he attached a condition. He wanted the collection to be shown in Pallant House, a Grade-1 listed Queen Anne town house dating from 1712, which since 1919 had been used as Council offices. Hussey wanted to make the specific point that good contemporary art can be at home in historic interiors. Betty Murray, then a District Councillor, championed his cause, and the Council accepted the gift with the conditions attached. From 1979 a restoration programme began, and preparations were made for the house to open in 1982; it would be a unique combination of historic house, furnished interiors and a modern art collection. In the early years the Council ran the house, but in 1985 a new body was set up. The Friends of Pallant House, under the leadership of the restaurateur Philip Stroud, had contributed generously to the restoration and refurbishment of the house, and it was decided that they would manage the enterprise together with representatives of the Council in an independent trust. Pallant House Gallery continues to operate under this structure.

Other collections followed. In particular, the Charles Kearley Bequest in 1989 was an important addition to the Gallery's holdings. Kearley was a property developer, racehorse owner and hotelier who built himself a modern house, designed by the architect John Lomax, at Hat Hill near Goodwood House, now the base of the Cass Sculpture Foundation, which runs Sculpture at Goodwood. In contrast to Hussey, whose collection was the result of his patronage of artists and his friendships with them, Kearley bought from dealers or at auctions, advised by, among others, the art critic R. H. Wilenski. He loved his art collection, particularly within the setting of modern architecture.

Some of Kearley's artists are also in Hussey's collection: Ivon Hitchens, Paul Nash and Ben Nicholson to name a few. Others widen the scope of the Gallery's collection: Sam Francis, Paul Klee, Fernand Léger, Jean Metzinger, Gino Severini and many more. The Kearley Bequest came to the Gallery as a whole through the National Art Collections Fund.

Peter Lanyon (1918–64)
The Green Mile (1952)

Oil on masonite
161 x 49.5 cm
Bishop Otter Collection,
University College
Chichester

Charles Kearley
at Hat Hill, Goodwood
(June 1981)

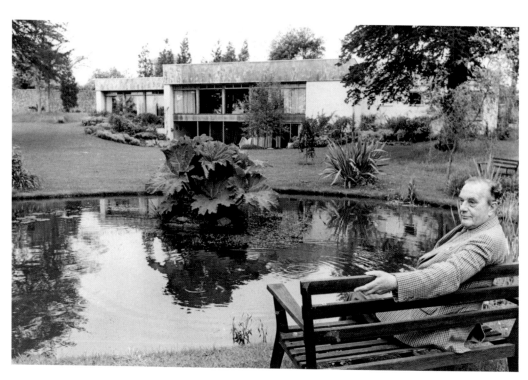

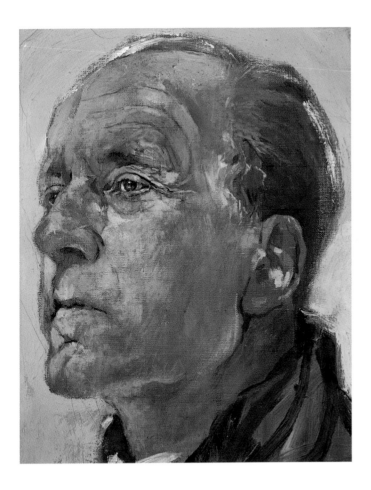

Graham Sutherland
(1903–80)
Portrait of Walter Hussey
(1965)

Oil on canvas
32 x 54.3 cm
Hussey Bequest,
Chichester District Council
(1985)

For example, when Mark Golder approached the Gallery only three years ago to enquire if it would like to be assisted with the acquisition of contemporary works by Scottish artists, a new dimension to the collection was added by the Golder-Thompson Gift, which continues to grow year by year. Interest on both sides was transformed into exemplary cooperation between a private benefactor and a public institution. There cannot be many galleries in England that are able to show the developments north of the border over the last 20 years, albeit through works on paper.

Collectors inspire others to follow in their footsteps. Dr John Birch, Master of the Choristers and Organist of Chichester Cathedral from 1953 to 1980, was stimulated by his Dean's collection and built up his own, which includes works by Jean Cocteau, Jacob Epstein, Duncan Grant, John Minton, Ceri Richards, Edward Wadsworth and many others. Again this collection is complementary to Hussey's and Kearley's, and it will eventually find the same home in Pallant House Gallery.

Friendship with artists, passion, intellectual and professional curiosity are all characteristics of the latest collection to come to the Gallery – that of Professor Sir Colin St John Wilson (Sandy to his friends) and his wife M J Long. Sandy Wilson describes his urge to collect as a 'lifelong addiction'. When, as a student, he chose to become an architect instead of a painter, his love of paintings was not easily suppressed. As soon as he had enough money he would spend it all on paintings, and earlier acquisitions would often be traded in as the only way of acquiring new ones. Sandy formed a number of friendships with artists like Peter Blake, Prunella Clough, Richard Hamilton and Eduardo Paolozzi through the Institute of Contemporary Art (ICA) in Dover Street and his association with the Independent Group (1952–55) and events such as the exhibition 'This is Tomorrow' in 1956 and the 'New Generation' exhibitions during the 1960s at the Whitechapel Art Gallery. As a result of his personal friendships he has been portrayed by Michael Andrews, William Coldstream, David Hockney, Howard Hodgkin, R. B. Kitaj and Celia Scott, and the whole collection is clearly structured by the group affiliations of the principal artists. He has written about the working procedures of Andrews and Coldstream in *The Artist at Work*. His collection gains special meaning through his interest as both a practising artist and a scholar fascinated by the working methods of other artists. Often both preparatory studies as well as the final work are represented. There is no doubt that the collection contains a number of icons of British twentieth-century art: Michael Andrews's *The Colony Room*, Peter Blake's *The Beatles 1962*, David Bomberg's *The Last Self-Portrait*, Patrick Caulfield's *Portrait of Juan Gris*, Lucian Freud's *Self-Portrait with Hyacinth in Pot*, Richard Hamilton's *Swingeing London '67* and Howard Hodgkin's *Grantchester Road*. Its importance can be measured by the fact that over 800 loans to exhibitions have been recorded in the last 25 years.

Over the years a steady stream of gifts, bequests and loans have enriched the collection due to the great tradition of generosity in this country. Also, the domestic scale of the Gallery makes it a proper recipient of works of art that have been chosen for private houses, one characteristic that links the Hussey and Kearley bequests. Another significant reason for collectors to give to a gallery of this size is the fact that their cherished collections do not disappear into vast storerooms, only reappearing occasionally, as is so often the case with large public galleries.

Meeting private collectors is most rewarding – they are passionate, knowledgeable and very often shrewd negotiators. They combine absolute conviction with a shy, sometimes defensive vulnerability. In many cases they reach a stage in which they want to share the fruits of their passion with others. Neither Kearley, Hussey nor any of the other collectors who donated their collection to Pallant House Gallery ever pretended that their collections were art historically comprehensive. They never collected 'a history of British art in the twentieth century'. The appeal of their collections lies in the very personal choices they made. Even so, all combined, a picture of the development of art in Britain clearly emerges.

The reasons for the gift to Pallant House Gallery are manifold. Sandy and M J have had a cottage in Bosham near Chichester for many years, mainly driven by the family's love for sailing, wind surfing and the sea. No more qualified an architect than M J, with her partner Rolfe Kentish, could have designed the new and acclaimed National Maritime Museum in Falmouth, transforming a personal love into a professional achievement. M J started her career as an architect working with Sandy Wilson on the British Library, his greatest achievement. Many still remember how this project was dogged by political indecision and manipulation. It is a pure miracle that after 30 years the library opened, a great accolade to the tenacity of Sandy Wilson who now reaps the praise and reward for a design that works to everyone's immense satisfaction. After devastating insults were heaped on the design and architect, destroying not only his practice but also those of other architects, M J Long set up her own practice in partnership with Rolfe Kentish and designed two libraries for the University of Brighton, studios for Frank Auerbach, Peter Blake, Paul Huxley, Ben Johnson and R. B. Kitaj, the Maritime Museum development in Falmouth and now the conversion of the Jewish Museum in Camden, London.

When Sandy Wilson and M J Long were looking for a home for their own collection they wanted to make sure that the works would be exhibited – in an ideal world – in an architectural environment over which they had a say. Because of Sandy's relationship with Cambridge, where he was Professor of Architecture and Fine Art from 1975 until 1989 and is still Emeritus Professor, the Fitzwilliam Museum was a strong candidate, but the scope for professional involvement was not realistic. In the early 1990s Pallant House Gallery had started to burst out of its seams, and a small development of new gallery spaces, on a plot at the back of the Gallery that was occupied by garages and tarmac, was considered. By that time Sandy Wilson and M J Long had identified the Gallery, close to their weekend cottage, as a possible recipient of their collection. The Trustees welcomed this major opportunity whereby distinguished architects could design the best possible environment for their nationally important yet also very personal collection.

The project was dependent on funding from the Heritage Lottery Fund. The fund would only commit itself to considering the application for a development grant if two conditions were met: a development on a larger plot through the acquisition of a 1936 office building adjacent to the Gallery and a European tendering procedure for the choice of architects.

In October 1997 three friends of the Gallery succeeded in buying the next-door office building, and a new brief for the architects was written. Following the guidelines of the European tendering procedure, invitations were sent out in spring 1998. Of the 25 practices who expressed an interest, five were invited to an interview. Long and Kentish Architects in association with Colin St John Wilson and Associates were chosen because of their professional response to the brief and their profound knowledge of the site, the house and the collections.

Some important architectural choices were made as a result of the always open and constructive dialogue with the architects. The idea of a large basement was ruled out

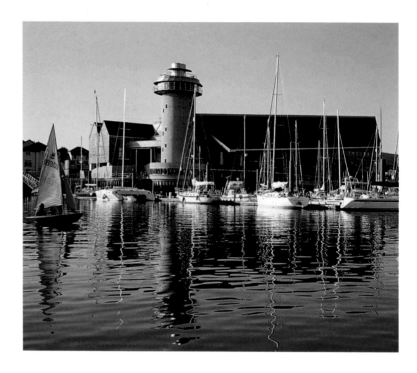

Top:
Long and Kentish Architects
Exterior of the National Maritime Museum, Falmouth (2003)

Left:
Colin St John Wilson and Associates
The Humanities Reading Room, British Library (1997)

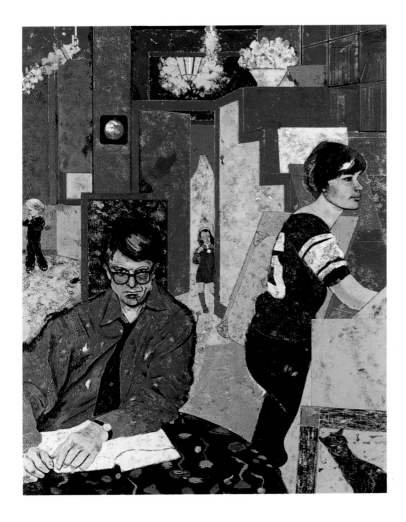

R. B. Kitaj (1932–)
The Architects (1981)

Oil on canvas
153 x 122.2 cm
Wilson Loan (2004)

because of the sensitive water levels on site, a potential danger to neighbouring properties. Furthermore, a variety of 'real' rooms was favoured, as opposed to a flexible space where curators would have to re-design the configuration of moveable panels for each new display. And, in any case, a painting does not hang comfortably on a panel.

The new galleries are located on the first floor of the extension, making it easier and more cost effective to maintain special environmental controls, and all public services and activities are dealt with on the ground floor. French doors opening on to the courtyard garden mean that fresh air and the changing seasons are integral to the visitor's experience. As a source of ambient lighting, natural light is living, changing and stimulating, introduced through the roof to maximise the run of wall space for display. The architect moved the roof lights as far away from neighbouring properties as possible so as not to adversely affect their light levels.

To ensure easy access for all, the main entrance is at street level rather than at the raised level of Pallant House, although it is permitted to use the main door to the house

on occasion. The difference in floor level between the old and new structures is resolved by the installation of a lift and staircase system serving all levels. The lift is positioned to enable full access to the house at a point where it least damages the internal fabric. A main characteristic of the new building is that, unlike most new gallery projects, nearly all space has been created for public use. For example, when a painting is being conserved, this will happen in the workshop in full public view. Offices and other behind-the-scenes spaces mostly remain as before. An effort to open the cellars of the house to the public failed due to fire regulations, though the lift goes down to that level so the option remains open if circumstances change.

It has been a huge challenge to the trustees, staff and architects to guide this project through planning rules and to raise enough money to guarantee the start of building. It is almost unheard of to add a contemporary structure to a Grade-I listed building in a conservation area in an historic town centre in England. Local and national interest, both in favour of the project and against, was enormous, mainly focusing on the new façade next to the house in North Pallant. As a principle it is right to combine the historic with the architecture of a different time, as has been done over many centuries; cities, towns and villages have grown organically, and on close inspection traces of many different ages often can be found, even in a single building. To do this is something to embrace and of which to be proud.

A variety of organizations including English Heritage, the Georgian Group, the Ancient Monument Society, the Commission for Architecture and the Built Environment, local committees and the Architectural Panel of the Heritage Lottery Fund all expressed an opinion. A first design for the façade, with a glass divide between house and new building, did not receive support from the Chichester District Council planning department and English Heritage and so it was never submitted. This was followed by further discussions and submissions until all parties approved the final design in August 2001.

Parallel to the planning procedure the capital application of £3.85 million to the Heritage Lottery Fund had been submitted and, after planning approval had been obtained, was granted in December 2001. The Chairman of the Pallant House Gallery Trust for ten years, David Hopkinson, stood down only a few days later amidst celebration of his achievements. He and his wife kept their promise of a donation of £1.5 million for an endowment fund for the running of the Gallery on condition that both planning permission and lottery monies were granted. This process had taken a year longer than planned, making it harder to fundraise the £8.9 million required, as the economic climate had changed dramatically in the intervening time. At the start of the works on 13 January 2003, only ten per cent of the total sum still had to be found. This was nevertheless an enormous challenge, though one that was eventually met.

During the subsequent detailed development of the designs some exciting choices were made. Firstly, Christopher Bradley-Hole was invited to design the courtyard garden. Many times gold-medal winner at the Chelsea Flower Show, he is a nationally and internationally renowned landscape architect. Also, after long debate, an environmentally sustainable heating and cooling system was chosen, a relatively new concept in Britain and only the second application of its type in England. The piling for the new building was used to incorporate a tube, filled with water, which runs through 59 piles. The water is pumped through this closed circuit, and the difference in temperature between a depth of 25 metres and the surface of the earth is used to cool in summer and to heat in winter. This system has been used successfully on the Continent for more than 40 years, but it is hugely disappointing that no government development agency chose to support the extra costs of installing this innovative and forward-thinking system. It potentially will provide a major step forward in the creation of a sustainable environment, as has happened already in countries like Austria, Germany and Switzerland.

With the completion of the redesign, the collection is able to be shown at its best throughout the house and the new gallery. The house, with its furnished domestic rooms, is different in character from the new gallery, but it forms an integral part of the chronological trail through the collection. Within that chronology, certain themes are highlighted. The emphasis is on British art from 1890 until the present, but there are also earlier important works of art, such as the Amberley Panels by Lambert Barnard (1490–1567/8), the portrait bust of Charles I by Hubert Le Sueur (c.1590–after 1658) and the cabinet with eight reliefs depicting Orpheus playing for the animals by Francesco Fanelli (1590–1675). Two further collections deserve mention: the Geoffrey Freeman Collection of Bow Porcelain and the Arthur Miller Collection of eighteenth-century Waterford crystal on display in cases in the café and regularly rotated to show the full range.

While the main part of the collection is by British twentieth-century artists, there are also important examples of work by international artists. Within the broad chronology, themes are chosen and will change regularly in the future. Regional developments with a national significance are illustrated: for example, Edward James's contribution to Surrealism and other contemporary art; the Church of England's role as patron of the arts; and the

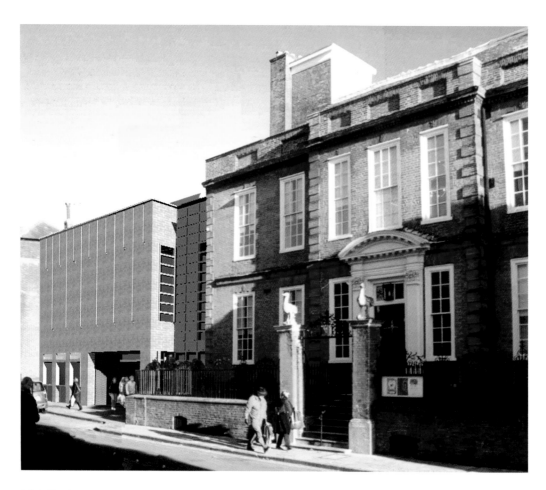

Long & Kentish architects, **in association with Colin St John Wilson & Associates**

Architects impression of Pallant House and the new wing (2002)

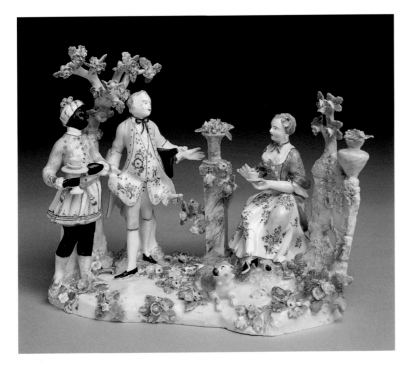

Bow Factory (c.1748–76)
Tea Party Group (c.1760)

Porcelain ware
20.6 cm high
Geoffrey Freeman
Bequest (1997)

Eric Gill (1882–1940)
Christ the King (c.1935)

Portland stone
39.4 cm high
Eric Gill Collection, West
Sussex Records Office,
Chichester

artists' community at Ditchling with Eric Gill and David Jones. Where possible, international artists and their work will expand the wider international story. It would be wonderful if the acquisition or loan of works by international artists were able to illustrate the influence of the Continent and the USA on British art in the twentieth and twenty-first centuries. After all, British art has never developed in isolation from outside influences.

The collection is very much alive and will be used to tell many different stories. It has been decided to combine a gallery and lecture room in order to show the whole reserve collection of works that are temporarily not part of a specific display but remain on view to the visitor. The collection is also open ended. Recent acquisitions, through artists' residencies and the 'Art for All' programme of affordable multiples, are works by jeweller Wendy Ramshaw, photographic artist Joy Gregory, the painters Peter Blake and Paul Huxley, sculptor Andy Goldsworthy and multi-media artists Langlands & Bell

The collection is not and certainly does not pretend to be a comprehensive history of twentieth-century British art, but as a whole it gives a good and informative impression. In addition the temporary exhibitions programme aims to be complementary to the collection in the wider sense. National and international artists, collections and themes shed a new light on familiar works in the permanent collection.

The most important result of the new development is the creation of strong community projects, making the Gallery a place where people are able to meet, learn, study, create 'hands-on' and enjoy themselves. Art and

creation do not exist when isolated from human action and interaction. In practical terms, this means a workshop for groups or artists in residence, a considerable art library with reading room, a café and, most importantly, a programme of lifelong learning, enjoyment and outreach. Everyone is invited to regard this extraordinary place as their own.

The London Modell
Pallant House and the historic collections

2

Although the works in Pallant House Gallery's collections are largely composed of British twentieth-century art, there are a number of important exceptions, in particular the magnificent Queen Anne town house that is the heart and soul of the Gallery. Dean Hussey's taste in art also ran to Italian Renaissance drawings, eighteenth-century British landscape paintings and costume design, as well as furniture. Other individuals have donated significant collections of non-twentieth-century work, such as the Geoffrey Freeman Collection of Bow Porcelain and unique pieces such as the Askew Cabinet. There are also a number of works relating to Chichester's history, such as the remarkable Amberley Panels and the portrait bust of Charles I, as well as a collection, part owned and part on loan, of works by the Smith brothers of Chichester.

The story behind the building of Pallant House is one of intrigue and scandal, not unlike any other construction project. This remarkable building was born out of the marriage of convenience of Henry Peckham, an ambitious yet disreputable 27 year old, and Elizabeth Albery, a widow in her early 40s. In 1710 Elizabeth had inherited a large fortune from her brother, Vincent Cutter, a childless widower who was a captain in the Royal Navy. Cutter had amassed holdings of Government and East India Company stock and also the lease of a house in Soho Square, London. As principal beneficiary of his will, Elizabeth's inheritance amounted to £10,000, an enormous sum of money at the time.

In 1711 Henry Peckham, in Elizabeth's words, 'made application […] with pretensions of great love & kindness & many fair promises in order to marriage'. Henry had inherited the troubled estate and debts of his father John in 1700 at the age of 16. On the advice of the estate's executor, Henry embarked on a career as an attorney, but at heart he really wanted to be a soldier and shortly left for the army under something of a cloud. Later, Henry acquired the nickname of 'Lisbon' Peckham, thought to allude to his future dealings as a wine merchant and the growing Anglo-Portuguese trade. However, by 1711 he had managed to pay off his father's debts. It was then that he approached Elizabeth's father for her hand in marriage and, not surprisingly, was greeted with some

suspicion. Negotiations followed, and eventually a pre-marital contract was agreed whereby Elizabeth received an annual payment of £50, from her own money, for her to spend as she chose and a lump sum of £2000 to be put aside for her to leave to whomever she wished in her will.

The marriage lasted for just over five years and ended acrimoniously with a lawsuit that dragged on until 1720, as both parties argued the financial settlement, much of the dispute concerning the final cost of building Pallant House. Elizabeth did not contest, however, that it was her idea to build a house in Chichester, or that she had made alterations to the building as it progressed, or even that she had insisted Henry dig into her fortune to pay the mounting bills. The one thing they shared was an ambition to make their mark on the city, and it is in no doubt that the house is the one good thing to have issued from this most unhappy union.

Costing in the region of £3000, just under double the original estimate, the building of Pallant House was spared no expense. On the site of an old malt house and near the city market, it swiftly rose above the surrounding Tudor buildings, with eight craftsmen working to a design taken from a contemporary London town house. No architect has been linked to the project, and it was a local stone mason, Henry Smart, who worked on the house and was responsible for creating its unique character, describing it as 'a New Modell […] Drawne at London'. The house is very much in the Classical revival style, as can be seen in the symmetry of the façade, the elaborate Corinthian columns flanking the doorway and in the detail of the screen on the upper landing inside. Everything was designed to impress, in particular the gateway, with Henry's initials interwoven in a wrought-iron arch and flanked by two stone ostriches from the emblem of his crest. The entrance hall, occupying an excessive one third of the entire ground-floor area, contains an elaborately carved oak staircase, which must have been the single most expensive feature of the building. As the first building of its kind in Chichester, it set the standard for the future developments that have given the city its Georgian character.

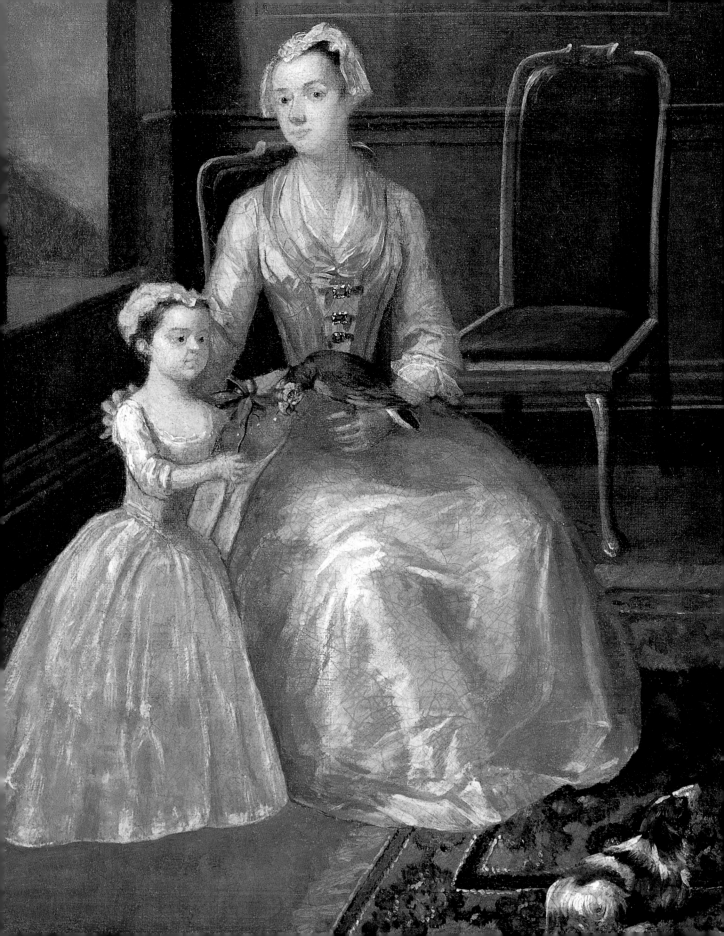

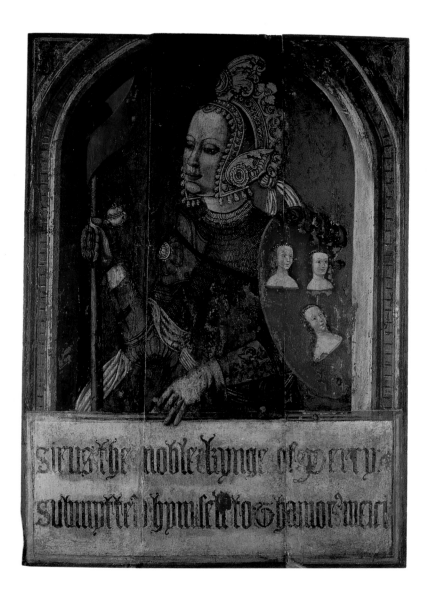

Lambert Barnard (*c.* 1490–1567)
Queen Thamoris of the Massagetae
From the Amberley Panels 'Heroines of Antiquity' (*c.* 1526)

Oil and tempera on wood panel
115 x 86 cm
Chichester District Council, purchased with support of the National Heritage Memorial Fund (1983)

This is one of the eight surviving Amberley Panels forming part of Barnard's decorative scheme for Amberley Castle, the former residence of the bishops of Chichester. Bishop Robert Sherborne occupied the post from 1508 to 1536, his diplomatic skills ensuring his survival through the religious turbulence of King Henry VIII's reign. It is thought that the Bishop engaged Barnard to paint the barrel-vaulted Queens Room to mark the King's visit to the Castle in 1526. Sherborne's choice of the heroines of antiquity as the subject of this series was appropriate to the Renaissance, when higher-class women were being encouraged to excel in intellectual and artistic pursuits.

These heroines, however, have more bloody attributes. Thamoris, for example, was the Queen of a barbaric tribe, who avenged her son's death at the hands of King Cyrus by subduing him in battle, beheading his nobles in front of him and subsequently executing Cyrus himself.

Barnard, now believed to be local to local to Chichester, was Sherborne's 'court painter', and his work includes two commemorative paintings and a series of portraits of kings and bishops, all in Chichester Cathedral, and the painted ceiling at Boxgrove Priory near by. These, together with the panels, are some of the few examples of early sixteenth-century work to survive in England.

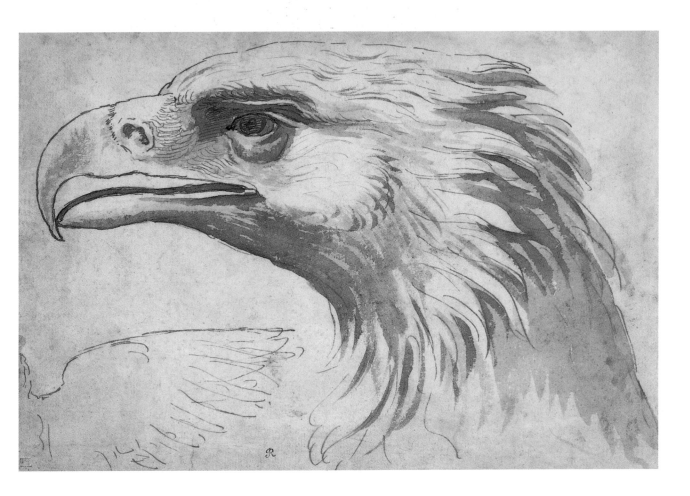

Giulio Romano (*c.* 1499–1546)
Head of an Eagle (*c.* 1526–28)

Pen, brown ink and wash on paper
14.9 x 22.2 cm
Hussey Bequest, Chichester District
Council (1985)

The Palazzo del Te in Mantua is one of the greatest villas of the High Renaissance, executed in the Mannerist style by the architect and artist Giulio Romano and built for Federico Gonzaga, the Duke of Mantua, one of the most cultivated of all art patrons. Romano, also known as Giulio Pippi and the principal assistant to Raphael, started work on the Palazzo in 1526, extending the Gonzaga stables to create an imaginative building filled with illusionistic fresco paintings.

This drawing is one of many studies Romano produced for the decorative scheme of the Palazzo. The eagle was a symbol of Imperial power and was conferred on the Gonzaga family by Emperor Sigismund in 1433. As the manifestation of the god Jupiter, the eagle represented absolute power as well as seduction, making it a potent heraldic device for Federico Gonzaga, and it was used throughout the Palazzo. This drawing is thought to have been a preparatory design for the gilded stucco eagles decorating the ceiling of the Camera delle Aquile (Room of the Eagles), the private room of the Duke. It illustrates the comment of Giorgio Vasari, Romano's biographer: 'Giulio always expressed his ideas better in drawings than in finished work or in paintings, displaying more vivacity, boldness, and expression.'

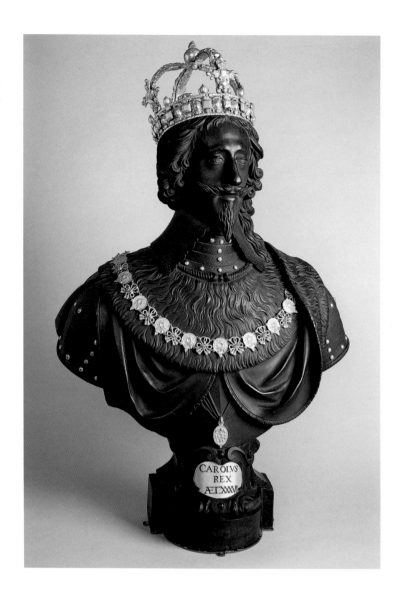

Hubert Le Sueur (*c.* 1590–after 1658)
Portrait Bust of King Charles I (*c.* 1637)

Gilded bronze
95 x 65 x 30 cm
Chichester City Council (2000)

The taste of King Charles I for classical and renaissance art and his interest in artistic developments on the Continent greatly influenced the arts in England during his reign. He patronised some of the most celebrated foreign artists and craftsmen of the time, including Anthony van Dyck, but in Pallant House Gallery there are two examples of work by lesser-known artists known to have been commissioned by the King.

Le Sueur, originally a sculptor in the court of King Henry IV of France, made this portrait bust. On his ascendancy to the throne in 1625, Charles I recruited him to his court, perhaps because of Le Sueur's reputation for large-scale equestrian statues since the King was an excellent horseman. His monument in Trafalgar Square of King Charles I on horseback is probably his best-known work. This bust stood in a niche on the Market Cross in the centre of Chichester for many centuries, after being presented to the city during the reign of Charles II in recognition of its role as a monarchist stronghold during the Civil War.

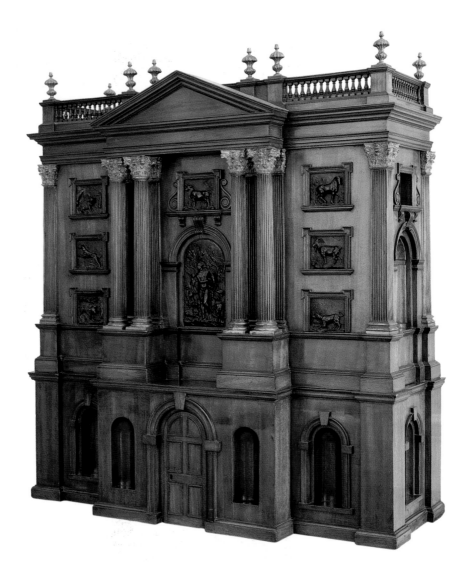

Francesco Fanelli (*c.* 1590–1675) and
Anon (eighteenth century)
The Askew Cabinet

Mahogany cabinet (*c.* 1740) inlaid with
leaded brass plaques by Fanelli (*c.* 1640)
119 x 111 x 47 cm
Presented by Ian Askew, through the
National Art Collections Fund (1986)

This is perhaps the most remarkable
piece of furniture in Pallant House
Gallery's collections: a cabinet of
curiosities possibly designed for a
collector in the court of Charles I and
incorporating a delicate series of reliefs
by the King's sculptor, Francesco Fanelli.
Opinions differ as to whether the
mahogany cabinet was created at
the time of the first Palladian revival
in the mid-seventeenth century,
reproducing in miniature the
architecture of Inigo Jones and his
contemporaries, or, more probably, the
later revival in the eighteenth century.
However, the cabinet was almost
certainly made by an architect, rather

than a furniture maker, due to the
accuracy and elegance of the
architectural detail and proportions.

The earlier date would collude with
the creation date of the plaques, which
were made at the time of Fanelli's
residence at the court of King Charles I
between 1631 and 1640. Referred to
as 'ffrancisco the one-eyed Italian' in
contemporary records, Fanelli
specialized in fashioning small bronzes
by using the lost-wax method. Here,
he has rendered the story of Orpheus
pacifying the beasts by singing to them
accompanied on his lyre, a popular
theme illustrating man's ability to bring
order to the chaos of nature.

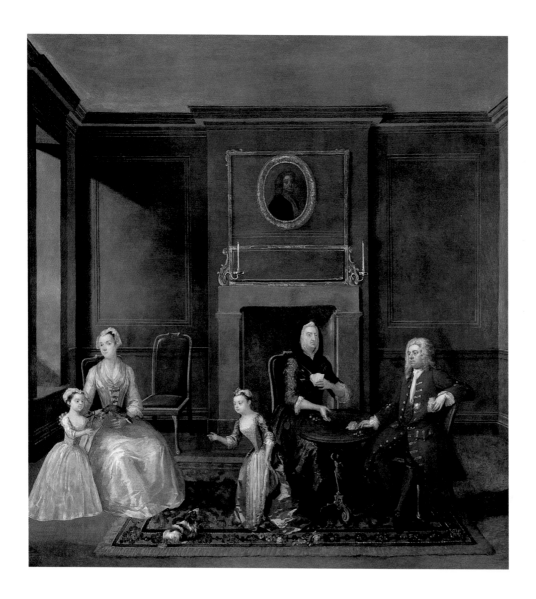

Gawen Hamilton (c. 1697–1737)
The Rawson Conversation Piece
(c. 1730)

Oil on canvas
80 x 74.6 cm
Purchased with support of the National
Art Collections Fund and the V&A
Purchase Grant Fund (1994)

George Vertue, the antiquarian and engraver, remarked on the death of the Scottish painter Gawen Hamilton in 1737: 'It was the opinion of many Artists […] that he had some peculiar excellence wherein he out did Mr Hogarth in Colouring and easy graceful likeness.' This painting of the Rawson family was previously attributed to William Hogarth, who was the more successful artist of the period and whose reputation has outlasted that of Hamilton. However, it lacks the liveliness for which Hogarth's portrait groups, or conversation pieces, were particularly noted, despite the fact that it is perhaps one of the more informal and naturalistic of Hamilton's works.

This type of painting became popular in the first half of the eighteenth century with the rise of the middle class in England and, with it, a growing demand for portraiture to record the intimate details of domestic life. It reflects an increasingly relaxed relationship between parent and child, as children were no longer expected to behave like adults and the benefits of play and the role of the mother in child rearing were increasingly recognized. The room in which the figures are set is typical of the early Georgian period and echoes the interior appearance of Peckham's Pallant House.

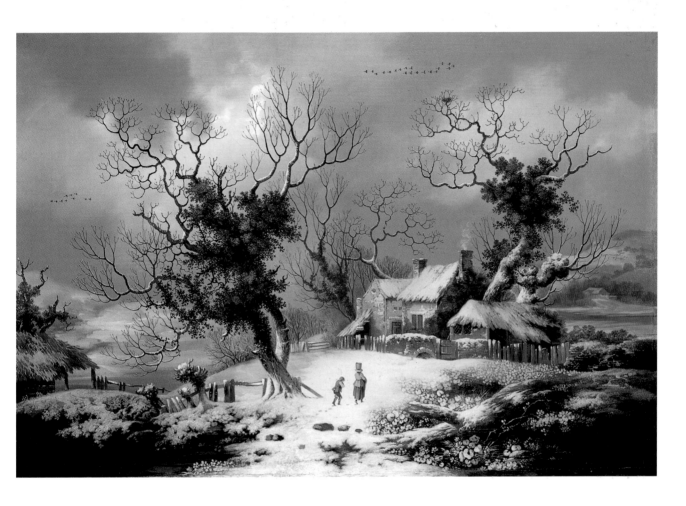

George Smith (*c*. 1714–76)
Winter Landscape (*c*. 1765)

Oil on canvas
43.8 x 64.2 cm
Purchased by the Friends of Pallant
House (1985)

The Smith brothers of Chichester – William (*c*. 1707–64), George and John (*c*. 1717–64) – were recognized as being among the foremost painters of their time, particularly in their representation of the English landscape. They contributed to the development of picturesque aesthetics by combining the classical pastorals of Claude Lorrain with rustic seventeenth-century Dutch landscapes.

George Smith was marginally the more successful artist of the three. At a time when British landscape painting was in its infancy, he won the first prize for landscape awarded by the Society of Arts in 1760, winning it again the subsequent two years. His brother John won the second prize. A reviewer

of the second Society exhibition in 1762 stated: 'The superiority of the Smiths as Landscape-painters is so incontestably visible to those who have the least judgement in Painting, or in Nature, that to declare my Opinion in this matter is quite unnecessary. Their pieces, in general, are finely imagined, accurately drawn, and chastly color'd.'

The 'frost pieces' of George Smith were particularly celebrated. This is a typical Smith composition, with figures of peasants and a humble cottage dwelling set within an exquisitely realized landscape that is characteristic of the Arun Valley near Chichester, where the brothers had lived since their youth.

Into the Twentieth Century
Sickert and his contemporaries

'**There is no such** thing as modern art. There is no such thing as ancient art. […] History is one unbroken stream. If we know Degas, Degas knew Ingres, and so on, *ad infinitum*.' So claimed the remarkably cosmopolitan artist Walter Sickert, whose career bridged the nineteenth and twentieth centuries. Sickert's pervasive influence is still felt in British figurative painting today, but his roots go back to the studios of Whistler, Degas and the French Impressionists.

Sickert had originally trained as an actor, but, after a brief period at the Slade School, he became the studio assistant of James Abbott McNeill Whistler in 1882. Four years previously Whistler had famously been accused by the critic John Ruskin of 'flinging a pot of paint in the face of the public' on account of the aestheticism of his approach to painting, with its concentration on the harmonious arrangements of colour and pattern over subject matter. Whistler made a plea for the autonomy of art, urging: 'Art should stand alone, and appeal to the artistic sense of eye or ear without confounding this with emotions entirely foreign to it.' He taught Sickert etching and painting, encouraging him to simplify and distil what he saw in terms of line and colour, and to achieve subtle modulations of tone.

In 1883 Sickert was entrusted with the task of conveying Whistler's *Portrait of the Artist's Mother* to the Paris Salon. Armed with letters of introduction, Sickert met Edgar Degas, was shown around Édouard Manet's studio and stayed with the playwright Oscar Wilde. The following year Sickert stayed with Degas in Dieppe, later describing his apartment as 'the lighthouse of my existence'. Degas was to be a powerful antidote to the aesthetic influence of Whistler as his work was based on the human figure in social contexts, particularly subjects in theatres and cafés. Besides Degas, Sickert was also to meet the artists Claude Monet, Camille Pissarro, Paul Signac, Pierre Bonnard and Édouard Vuillard. Out of these formative experiences Sickert created his own distinctive approach to the representation of modern life, which was greatly removed from what he described as 'the wriggle-and-chiffon school' of late Victorian and Edwardian art. It focused on the 'magic and poetry' that was to be found in everyday life.

Sickert's art combined a concern with realism, informal compositions and an innovative paint technique that employed rich tonal harmonies and strong colours. He wanted his pictures to be like 'pages torn from the book of life'. Finding visual interest and excitement in the mundane, he painted urban and suburban landscapes, figures in seedy domestic interiors and cockney music-hall subjects. 'The more our art is serious, the more it will tend to avoid the drawing room and stick to the kitchen,' Sickert claimed. Focusing on the essentials in a scene, he emphasized momentary gestures and poses and, with bravura highlights, the effect of the fall of light. He was a prolific printmaker and believed that prints should be a popular and informal form of art, often basing them on his favourite compositions in other media and vice versa, so that there was a creative interrelationship between his prints and paintings. In this attitude Sickert anticipated that of the Pop artists of the 1960s.

From 1898 to 1905 Sickert lived in the French seaside town of Dieppe, with long visits to Venice. It was in Dieppe that he met the artist Spencer Gore in 1904, and, despite an age difference of 18 years, they soon became close friends, sharing a studio and learning from each other's use of colour. On his return to England, Sickert took rented rooms at 6 Mornington Cresent in Camden Town and kept an open house at his studio in 8 Fitzroy Street on Saturday afternoons. In 1907 the artists who attended this open house formed the 'Fitzroy Street Group'. They rented the first floor of the house opposite Sickert's studio, and each artist provided an easel to display an example of their own work. This informal arrangement of exhibitions and discussions on Saturday afternoons provided an alternative to art dealerships and attracted loyal clients. In 1911 the more advanced members of the group – Robert Bevan, Harold Gilman, Gore, Augustus John and Lucien Pissarro – formed the core of a more public organization, which was named the 'Camden Town Group' after the district of London that Sickert claimed was 'so watered with my tears that something important must sooner or later spring from its soil'. These artists varied in their aims and styles, but their pictures were generally based on everyday life and painted with a technique that can be loosely described as Impressionist with broken touches and bold colour.

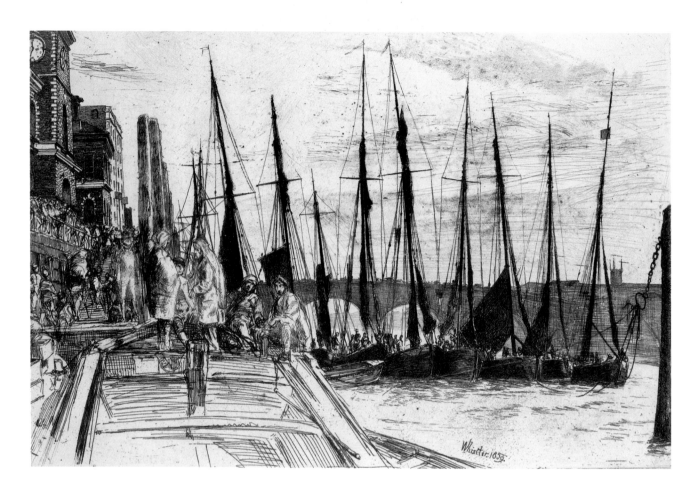

James Abbott McNeill Whistler
(1834–1903)
Billingsgate (1859)

Etching on paper
17 x 23.5 cm
Hussey Bequest, Chichester District
Council (1985)

In 1859 Charles Baudelaire urged artists to turn to a new genre: 'the landscape of great cities [...] the profound and complex charm of a capital city which has grown old and aged in the glories and tribulations of life'. Whistler, arriving in London from Paris in 1859, took rooms in Wapping from August to October and embarked on a series of etchings documenting life along the Thames, which became known as the 'Thames Set'. They synthesized related ideas regarding the construction of pictorial space that range from seventeenth-century Dutch interior paintings to photography (invented 1839) and Japanese *ukiyo-e* prints by artists such as Hiroshige, particularly in

the flattening and compartmentalising of space.

Whistler wanted to make each plate 'a little portrait of a place'. He appreciated the picturesque disrepair of the wharfs and warehouses, structuring his compositions around the traders and workers connected with the river. The most westerly site chosen along the Thames was Billingsgate fish market, which was probably etched from Custom House Stairs. A view of London Bridge and the tower of St Saviour's Church (Southwark Cathedral) is visible in the background. As the composition was not reversed, however, the scene appears 'the wrong way' round.

Walter Richard Sickert (1860–1942)
*Les Arcades de la Poissonnerie, Quai
Duquesne, Dieppe (c.1900)*

Oil on panel
19.5 x 15.7 cm
Hussey Bequest, Chichester District
Council (1985)

At the turn of the century the seaside
town of Dieppe was one of the most
fashionable resorts in France, and many
artistic and literary figures including
Oscar Wilde, Aubrey Beardsley, Marcel
Proust, Camille Pissarro and André Gide
stayed there. Following the breakdown
of his marriage, Sickert moved to
Dieppe in 1898 and remained there for
the next seven years. He concentrated
on painting the town, capturing the
spirit of the urban landscape with an
informal naturalism. His friend the
French painter Jacques-Emile Blanche
described him as the 'Canaletto of
Dieppe' and wrote of how, 'No other

artist has so perfectly felt and
expressed the character of the town'.

This painting of the arcades of the
fish market, which are next to the
harbour, is painted with great freedom
and loose drawing despite its small
scale. It is inscribed in ink 'To Mrs Price,
son très humble serviteur Sickert'. Mary
Price developed a close friendship with
Sickert, giving him a number of her
husband's clothes, and in return she
was taken to visit Edgar Degas's studio
in Paris. Price later acted as his Scottish
agent in the 1920s, keeping half of the
proceeds of anything sold and any
pictures she was not able to sell.

Walter Richard Sickert (1860–1942)
Study for *Jack Ashore* (*c*.1912)

Pencil on paper
34.3 x 25.4 cm
Wilson Gift, through the National Art
Collections Fund (2004)

Walter Richard Sickert (1860–1942)
Jack Ashore (1912)

Oil on canvas
38 x 30.5 cm
Wilson Gift, through the National Art
Collections Fund (2004)

The nudity of the female in this intimate scene of a couple in a dingy interior seems to be somehow unremarkable. However, the juxtaposition of clothed man and naked woman was shocking to the English pre-war audience. In his 'domestic conversation pieces' Sickert often explored the psychological relationship between a man and a woman, imbuing it with a sense of apathy, conflict or exhaustion. He was interested in the compositional problem of placing two figures at right angles – the head of the clothed man is cropped, and all attention seems to be concentrated on the woman's body.

Sickert has used a wide range of tones of paint to render the effects of light on her flesh. The rough textural handling of paint is typical of Sickert's highly original approach to oil painting, while the treatment of light and shade illustrates his debt to Edgar Degas.

The title may refer to the past of Sickert's model, Hubby, as a sailor. Hubby was a childhood friend of Sickert who ran away to sea and later fell on hard times. Marie Hayes, the female model in this painting, was not able to prevent Hubby from drinking and mixing with the criminal underworld.

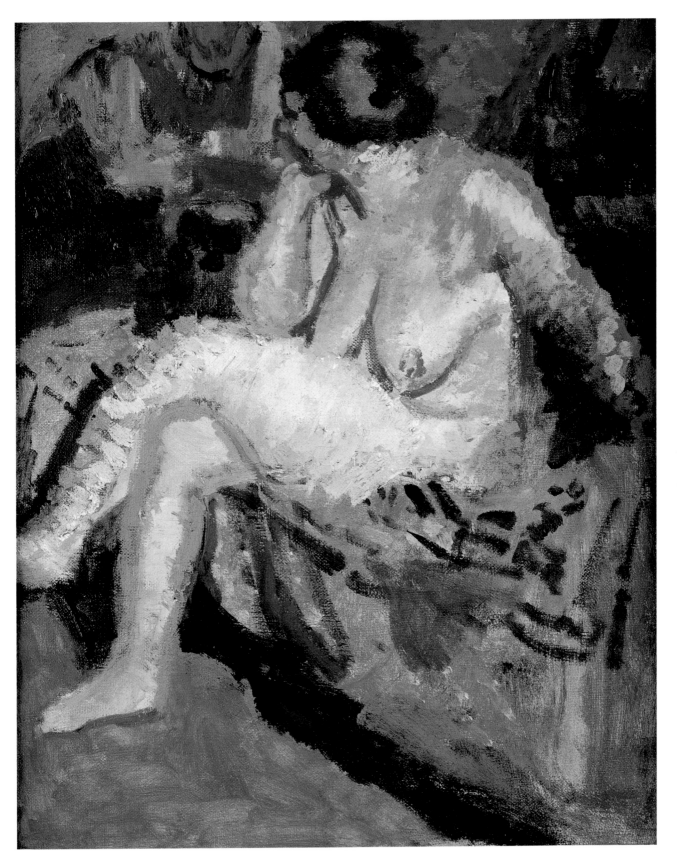

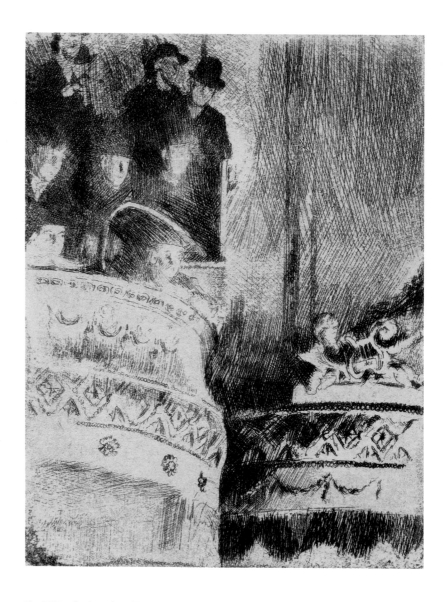

Walter Richard Sickert (1860–1942)
The Old Bedford (1910)
(The Small Plate)

Etching on paper
Platemark 11.1 x 8.5 cm
Wilson Loan (2004)

The Old Bedford Music Hall in Camden Town was one of Sickert's favourite haunts and the inspiration for a series of paintings, drawings and prints. William Rothenstein described how, when Sickert was in London, he would go there nightly 'to watch the light effects on stage and boxes, on pit and gallery, making tiny studies on scraps of paper with enduring patience and with such fruitful results'. For this print, with its subtle tonal variations, Sickert used sketches from the 1890s.

The Old Bedford was pulled down in 1898 after a fire and opened on the same site the following year as the New Bedford. Writing in 1910, Sickert fondly recalled 'the old Bedford Music Hall, the dear old oblong Bedford, with the sliding roof, in the "days beyond recall" before the Music Halls had become two-house-a-night wells, like theatres to look at'.

Sickert was a highly original printmaker, often employing innovative subject matter. Here he turned his attention to the gawping spectators in the gallery, in their bowler hats, instead of the action on the main stage. In 1910 he founded Rowlandson House, a school for etching, at 140 Hampstead Road, where his students included Sylvia Gosse and Thérèse Lessore.

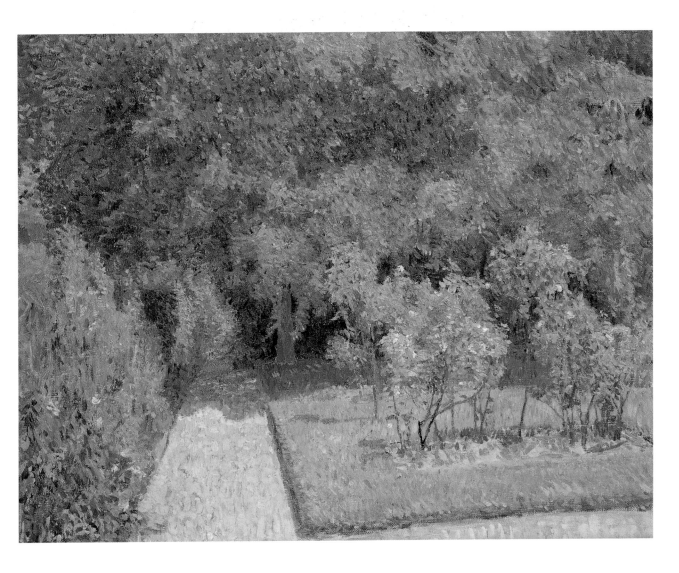

Spencer Gore (1878–1914)
The Garden Path, Garth House (1910)

Oil on canvas
41 x 50.8 cm
Hussey Bequest, Chichester District
Council (1985)

This serene view of afternoon light falling on rose beds and gravel paths was painted in the garden at Garth House, Hertingfordbury, which was the home of Gore's mother. Gore visited the house for extended periods between 1907 and 1910, working in the garden to produce images of nature that contrast with the urban scenes that he painted in London. As a member of the New English Art Club and the Fitzroy Street Group, and later as President of the Camden Town Group, Gore was closely involved with aesthetic debates in the capital.

This painting reveals Gore's remarkable ability to render light by manipulating colour with a form of modified divisionism composed of individual flecks of colour – blues, pinks and purples – that give richness and depth to the foliage. Art critic Jack Wood Plamer, writing in 1955, regarded such pictures as the quintessence of the Edwardian era. 'In this garden,' he wrote, 'with its ilex and poplars in a stilled radiance of light, the gravel paths along which frilled muslin skirts have lightly swept, the roses heavy in their Chinese moment of perfection, it is always afternoon, and Gore's paintings of it are among the most exquisite evocations of the Edwardian era.'

Art Quake!
Modern British art, 1910–25

When the novelist Virginia Woolf wrote of how 'on or about December 1910 human character changed' she was referring, not only to the changes in society signalled by the growing militancy of the Suffragette movement and by the Welsh miners strike but also to one of the most influential art exhibitions held in Britain during the twentieth century. This landmark exhibition, entitled 'Manet and the Post-Impressionists', was organized by the critic and connoisseur Roger Fry to fill a gap in the programme of the Grafton Galleries in London. Featuring the work of a number of modern French artists, most of whom had never before been seen in England, it formed a challenge to prevailing Edwardian tastes and values, prompting enormous controversy in the newspapers. It was, in the memorable words of Desmond MacCarthy, 'the Art Quake of 1910'; while for others, such as the outraged critic of *The Times*, C. J. Weld-Blundell, it was 'like anarchism in politics […] the rejection of all that civilization has done'. For many British artists the exhibition was a revelation, exposing them to exciting developments in continental avant-garde art. Besides Manet, the exhibition included 21 Cézannes, 37 Gauguins and 20 van Goghs, as well work as by André Derain, Aristide Maillol, Henri Matisse, Pablo Picasso, Odilon Redon, Georges Rouault, Georges Seurat and Maurice de Vlaminck.

Roger Fry saw in these artists a return to the formal values he admired in Italian Renaissance art, and he placed emphasis on their use of flat pattern-like colour, line, scale, interval and proportion. In particular, Fry stressed the importance of Paul Cézanne and his links to Old Master painting, wishing to position Cézanne as the 'father of modern art'. For a generation of artists, both on the Continent and in Britain, Cézanne was a huge influence. His impact is particularly evident in the art of Fry, Vanessa Bell and Duncan Grant, who were part of the varied group of intellectuals and artists, which also included Virginia Woolf, the biographer Lytton Strachey, the economist John Maynard Keynes and the art critic Clive Bell, who lived in the area of London known as Bloomsbury. Their art was characterized by sensuous content combined with a Cézannesque concern for formal balance and bold colour, inspired by Matisse, whose Paris studio Duncan Grant had visited in 1909. Matisse's Fauvist (or 'wild') use of colour was also to be an enduring influence on the work of Matthew Smith, who had attended his atelier in 1911. Smith used vivid colour in

a non-naturalistic way to achieve spatial effects and modelling in a notable series of sensuous 'red nudes'.

In 1912 Fry and Clive Bell organized 'The Second Post-Impressionist Exhibition', which also included paintings by the Cubists and the English Bloomsbury Group. The Cubists, led by Picasso, Georges Braque and Juan Gris, presented a fragmented and subjective response to the world in their art, employing a multiplicity of viewpoints to render a new concept of space. 'These artists do not seek to give what can, after all, be but a pale reflex of actual appearance, but to arouse the conviction of a new and definite reality,' wrote Fry in the catalogue. 'They do not seek to imitate form, but to find an equivalent for life.' Earlier that year the Italian poet and impresario Filippo Tommaso Marinetti had brought his exhibition of Italian Futurist painters to the Sackville Gallery. It introduced the work of the Italian artists Umberto Boccioni, Carlo Carrà, Luigi Russolo and Gino Severini to the British public with as much sensationalism as Fry's earlier exhibition. Like the Cubists, the Italian Futurists, with their emphasis on modern urban life, the dynamic sensation of speed and the beauty of the machine, were to be a powerful stimulus for British artists.

Vorticism, the aggressive avant-garde movement founded by Wyndham Lewis in 1914, owed a clear debt to the Futurist's energetic concerns, despite the fact that Lewis was vehemently to attack Marinetti in his magazine *Blast*. The Vorticists, who included Jacob Epstein, Henri Gaudier-Brzeska, the poet Ezra Pound and William Roberts, wanted to jolt Britain out of its insularity and complacency through an energetic abstract art celebrating what Lewis described as 'the forms of machinery, factories, new and vaster buildings, bridges and works'. The energy of the Vorticist movement was dissipated by the war, which, ironically, it had celebrated. However, Vorticism was to influence considerably the development of British Modernism. Although not Vorticist, Ivon Hitchens was to express an understanding of Cubo-Futurism, gained through his reading of Bloomsbury criticism, in his painting *Curved Barn*, which was exhibited in the Seven and Five Society exhibition of 1922.

Those artists and critics who, during this period, were aware of, and engaging with, continental avant-garde art were to lead British art away from the insularity and isolationism of Edwardian society. The new forms of their art heralded a bold and exciting future and mirrored the enormous social change of the period.

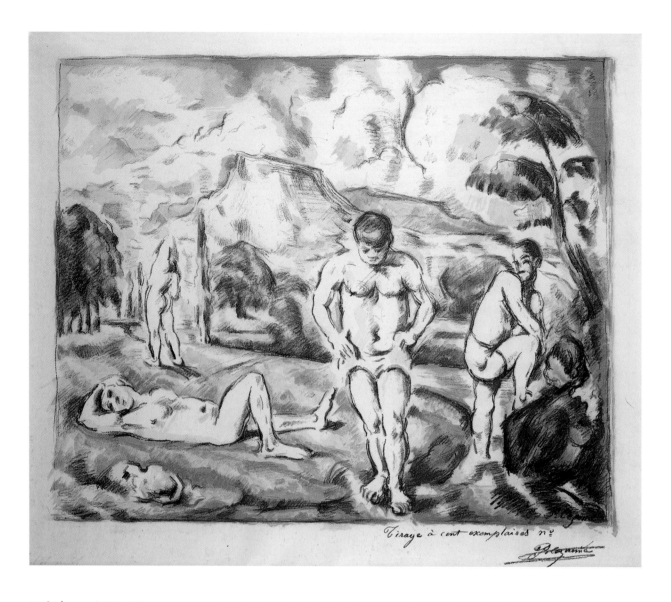

Paul Cézanne (1839–1906)
Les Grands Baigneurs
(The Great Bathers) (*c.* 1896–97)

Lithograph on paper
44.8 x 50.7 cm
Kearley Bequest, through the National
Art Collections Fund (1989)

Bathers were an enduring theme in Cézanne's art, enabling him to depict nature while paying homage to classical values in art. The artist once claimed that he wished to 're-do Poussin from nature'. The monumental figures in this image take various classical poses but are as integrated with nature as the rocks and trees. In the distance there is the distinctive form of Mont Sainte-Victoire, the mountain near Aix-en-Provence that Cézanne painted repeatedly in his later years. The emphasis on underlying form and the overall unity of all the elements gives the image great stability. In January 1911 the critic and collector Hugh Blaker wrote: 'Those bathers of

Cézanne! You can trace their genesis through the centuries to El Greco – almost to Masaccio.'

This lithograph was a reworking of the celebrated picture *Les Baigneurs au Repos*. It was commissioned by his agent, Ambroise Vollard, who included two lithographs of Cézanne's bathers in his first album of prints by a number of contemporary artists, which was published in the 1890s. This unnumbered lithograph is the so-called 'Grande Planche' from that album, possibly a proof copy, and was formerly in the collection of Sir Michael Sadler, one of the first British collectors to obtain work by Paul Gauguin and Cézanne.

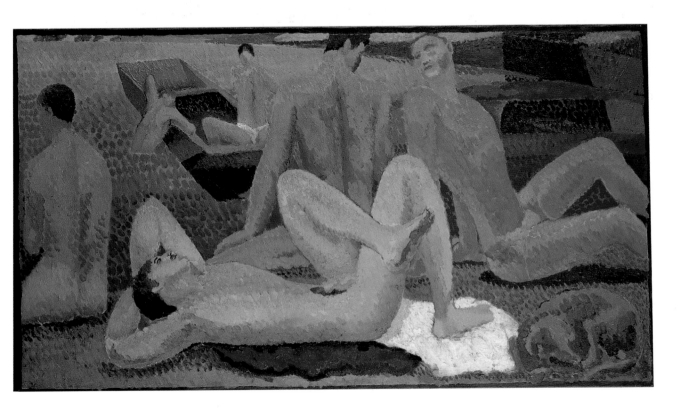

Duncan Grant (1885–1978)
Bathers by the Pond (*c*.1920–21)

Oil on canvas
50.5 x 91.5 cm
Hussey Bequest, Chichester District
Council (1985)

The setting of this languid bathing scene is the pond at Charleston Farmhouse, near Lewes in East Sussex, where Grant settled with Vanessa Bell in 1916. The warm colour and stippled paint surface reflect a renewed engagement with modern continental art and a return to Grant's 'spotted' painting style of the early 1910s. In 1919 the Bloomsbury artists had hosted André Derain and Pablo Picasso, and in December that year Grant had persuaded his friend the economist Maynard Keynes to buy Georges Seurat's oil study of 1884–85 of the standing couple toward the right of his famous Pointillist painting *A Sunday on La Grande Jatte*. The seated figure viewed from the back at the left of Grant's *Bathers* echoes a seated nude at the left of Seurat's *Les Poseuses*.

In painting a bathing scene the artist was consciously painting a Cézanne subject. However, while Cézanne sometimes painted male bathers as a result of his well-known shyness of female models, for Grant this represented a homoerotic fantasy world that was continuous with his life at Charleston. The idea of a male bathing scene was an abiding concern for Grant, and he later painted a larger but less successful painting of nine male figures.

André Derain (1880–1954)
Nature Morte au Pichet de Grès
(Still Life with Stoneware Jug) (1910)

Watercolour and pencil on paper
13.5 x 11.5 cm
Kearley Bequest, through the National
Art Collections Fund (1989)

Derain was part of the group of artists, including Henri Matisse, Kees van Dongen and Maurice de Vlaminck, who were called 'Fauves' or 'wild' when their work was exhibited at the Paris Salon d'Automne in 1905, on account of their free and spontaneous use of brilliant colours. However, within a few years Derain was to abandon the bright colours of the Fauves in favour of muted cooler colours and bold compositions influenced by the Cubists, in particular his friends Pablo Picasso and Georges Braque.

The subject matter and angle of this drawing also reveals a close personal appraisal of Cézanne's still lifes. Objects are reduced to basic geometric forms in adherence to Cézanne's dictum: 'See in nature the cylinder, the sphere and the cone.' This is a study for one of the most important paintings from Derain's Cubist period, *Nature Mort à la Table*, which is now in the Musée d'Art Moderne de la Ville de Paris. Its composition is orientated to the surface of the picture, rather than to conventional rules of perspective, and it is in many ways more dynamic than the finished painting, with greater distortions and an almost aerial viewpoint.

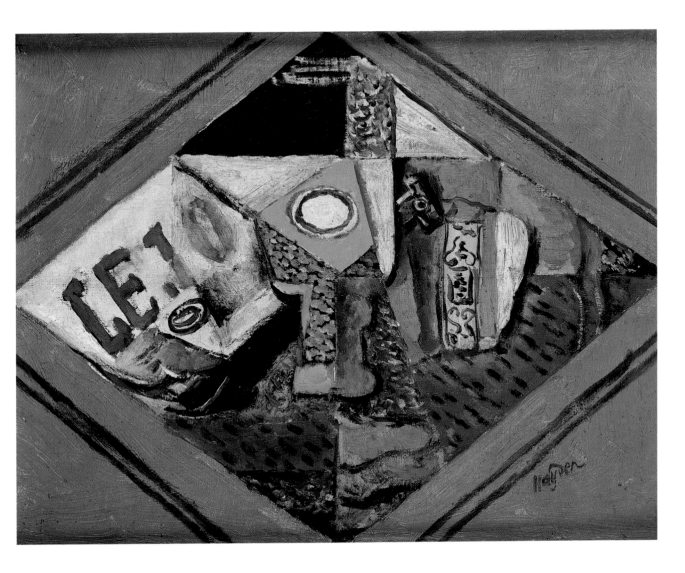

Henri Hayden (1883–1970)
Cubist (1919)

Oil on canvas
27.1 x 35 cm
Kearley Bequest, through the National
Art Collections Fund (1989)

Hayden was Polish by birth, but after studying at the Warsaw School of Fine Arts he moved to Paris in 1907, where he remained for the rest of his life. He was greatly influenced by Cézanne's work, particularly after seeing the retrospective in 1911, but was gradually drawn toward Cubism. In 1915 he was introduced to Juan Gris by the sculptor Jacques Lipchitz. The two painters became good friends, and Gris introduced Hayden to the Cubist dealer Léonce Rosenberg who gave him a contract.

During this period Hayden produced a number of Synthetic Cubist still-life paintings, such as *Cubist*, which was painted in the year of his one-man exhibition at the Rosenberg Gallery. This tableau incorporates the banner from the newspaper *Le Journal*, a pipe and a glass set into a diamond-shaped inner frame, which corresponds to the tabletop. It is composed according to the Section d'Or (Golden Section), a mathematical proportion held to be of great significance by the Cubist painters, in which a straight line or rectangle is divided into two parts in such a way that the ratio of the smaller to the greater part is the same as the greater to the whole.

Mark Gertler (1891–1939)
Near Swanage (1916)

Oil on board
24 x 36.2 cm
Kearley Bequest, through the National
Art Collections Fund (1989)

Gertler was born in the East End of London to poor Polish-Jewish immigrant parents. In 1908 he was enabled by the Jewish Educational Aid Society to go to the Slade School, where his fellow students included Dora Carrington, with whom he was later to have a relationship that lasted until 1917. Through Carrington he became associated with the Bloomsbury Group, and he regularly stayed with the Bloomsbury artists and writers at Garsington Manor, the home of Philip and Lady Ottoline Morrell. Like the Bloomsbury artists, he was influenced by Post-Impressionism, but his style was highly individual.

This picture was probably painted in December 1916 while Gertler was staying at Peveril House in Swanage, Dorset, the home of the Francophile collector Sir Montague Shearman, also a Jew and a devoted friend. The scene has an impression of serenity, an aspect of life that Gertler, a pacifist, was endeavouring to seek during World War I. In a letter to Carrington he wrote: 'From every window one gets a good enough view for painting [...] The sea surrounds the house on two sides. There is just a bit of garden and then cliff, below that is the open sea!'

Roger Fry (1866–1934)
Southern France (n.d.)

Gouache on buff paper
24.5 x 33.2 cm
Kearley Bequest, through the National
Art Collections Fund (1989)

Described by art historian Kenneth Clark as 'incomparably the greatest influence on taste since Ruskin', Fry became Britain's most famous writer on art between World War I and his death in 1934. He was the author of *Vision and Design* (1920) and *Transformations* (1926), both collections of influential essays, as well as *Cézanne* (1927) and *Matisse* (1930). Fry was also a painter, and throughout the 1920s he spent extended periods in the South of France, where Cassis and St Tropez became almost second homes to him. Here the sophisticated critic revealed a different aspect to his character. In 1926 the French writer André Salmon noted:

'Nobody is surprised when they see Mr Roger Fry in a large vine-dresser's hat, and very much at his ease in the blouse of a fisherman, appearing on the quay at St Tropez.'

Through the interplay of horizontals and verticals in this dramatic study of 'the bare, bald, grey mountains' of the Provençal landscape, Fry was putting his formalist criticism into practice. 'I daresay my "taste" in landscape",' he wrote to Vanessa Bell from St Rémy in 1927, 'is mixed with all sorts of irreverent romanticisms and vague associations but [quoting Cézanne] it's *plus fort que moi* [stronger than I am].'

Jean Metzinger (1883–1956)
L'Echafaudage
(The Scaffolding) (n.d.)

Oil on canvas
27.2 x 35.2 cm
Kearley Bequest, through the National
Art Collections Fund (1989)

Described by André Salmon in 1911 as 'the young prince of Cubism', Metzinger was one of the earliest devotees of Cubism. He met the writer Max Jacob in 1908 and was introduced by him to the poet Guillaume Apollinaire and his circle, which included Georges Braque and Pablo Picasso, who were to have a profound influence on his art. He was the first to note in print that they had dismissed traditional perspective and merged multiple views of an object in a single image, and he participated with Robert Delaunay, Albert Gleizes and Fernand Léger in the controversial Salle 41 at the Salon des Indépendants, the first formal group exhibition of Cubist painters in 1911. The following year he collaborated with Gleizes on *Du cubisme*, in which a theoretical foundation for Cubism was proposed, and he was a founder of the Section d'Or group.

The dynamic scaffolding of *L'Echafaudage* forms a device for leading the eye into the flattened space. There is a strong emphasis on diagonals that organize the space, with buildings reduced to geometric forms. Indeed, Apollinaire wrote in 1913: 'His art, always more and more abstract, but always charming, raises and attempts to solve the most difficult and unforeseen problem of aesthetics.'

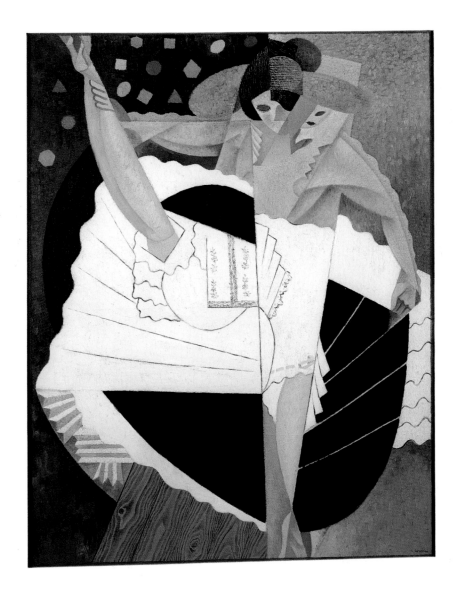

Gino Severini (1883–1966)
Danseuse No. 5
(Dancer No. 5) (1916)

Oil on canvas
93.3 x 74 cm
Kearley Bequest, through the National
Art Collections Fund (1989)

The subject of the dance was one of Severini's favourite themes, which he frequently used to express Futurist theories of dynamism in art. Severini had joined the Futurist group at the invitation of the poet Filippo Tommaso Marinetti in 1910, and he was a signatory of the *Manifesto of Futurist Painters*. However, the dance-halls and cabarets of Montmartre, which he frequented with his friends Guillaume Apollinaire, Amedeo Modigliani and Pablo Picasso, provided him with greater inspiration than the subject of the machine, which was used by the other Futurist artists to express dynamic movement.

The effect of movement is in part created by the fusion of the figure of the dancer with her surroundings by the penetration of colour and light. The insertion of mock materials (the wooden dais) reflects the collage aesthetic of analytical Cubism, and the decorative arabesque marks a stage of the process leading to the geometrical abstractions Severini produced in late 1916. Severini claimed: '"Inspired by movement" does not mean that I proposed to render the optical illusion of a thing or body that changes its place in space. My aim was to create, making use of that context, an even newer and more vital whole.'

Matthew Smith (1879–1959)
Reclining Nude (Vera) (1924)

Oil on canvas
49.5 x 64 cm
Presented by Mrs Margot Simon (1997)

Smith met Vera Cunningham, the model for this painting, in 1923 when she was posing for his friend Bernard Meninsky, a fellow member of the London Group. Vera was herself a painter and soon became Smith's lover and the inspiration for some of his most intimate and spontaneous figure paintings. The series of 'red nudes' that he painted in Paris during the winter of 1923–24 represent a highly individual response to Matisse's approach to colour and form. Smith was originally from the industrial north of England, but after studying at the Slade School he had attended Matisse's atelier in 1911.

In this painting, colours are paired with their opposites: red is complemented by green and blue with orange. It was thought that a colour placed next to its complementary appeared more vivid and intense. Through such colour contrasts Smith was able to suggest spatial recession, and to achieve modelling using colour to define rather than merely complete the form. 'It is upon colour that he lays the task of situating planes in the spatial and plastic construction,' Roger Fry wrote of Smith in 1926. 'Upon colour, too, he relies to achieve the suggestion of chiaroscuro. In all this he is pushing to the furthest limits the essentially modern view of the functional as opposed to the ornamental role played by colour in pictorial design.'

Ivon Hitchens (1893–1979)
Curved Barn (1922)

Oil on canvas
66 x 98 cm
Presented by the artist in memory
of Claude Flight (1979)

One of the earliest paintings by Hitchens, *Curved Barn* takes as its subject the old barn at Bex Mill, Heyshott. The subject was less important to the artist than the technique with which he depicted it, and he later described the painting as 'an essay in essential form and the dynamic relation of one plane to another'. Hitchens had read the writings of Roger Fry and Clive Bell on 'significant form' and had been awoken to an interest in Cézanne. Bell had asked in 1914: 'Who has not, at least once in his life had a sudden vision of a landscape as pure form? For once instead of seeing it as fields and cottages he has felt it as lines and colours.'

Hitchens believed that art was to be realized through structure rather than imitation. He was interested in theosophic ideas and the Japanese concept of 'notan' – a beauty that resulted from the manipulated harmony of light and dark spaces. *Curved Barn* is painted in sombre tones, with dynamic rhythms reflecting the influence of the Futurists. Hitchens later recalled being inspired by the work of the contemporary French 'naturalist' painter André Lhote, who was keenly supported by the Bloomsbury critics.

Blue Remembered Hills
A return to tradition between the wars

In 1919, writing for *The Studio*, C. R. W. Nevinson, a leading proponent of Vorticism and champion of Italian Futurism, expressed the feelings of many artists: 'The immediate need of the art of today is a Cézanne, a reactionary, to lead art back to the academic traditions of the Old Masters, and save contemporary art from abstraction.' In the wake of World War I, the rebel artists of the previous decade felt a sense of despondency over avant-garde art, linking the mechanistic style of Vorticism with the destructive force of war. The 1920s were characterized by: a retreat to traditional means of representation and techniques, such as wood engraving, and timeless subject matter, such as landscape and still life; an emphasis on formalism rather than invention; and the supremacy of the individual over the collective. Even the leading art group of the period, the Seven and Five Society, founded in 1919 and including such diverse artists as Ivon Hitchens, David Jones, Ben Nicholson and Christopher Wood, initially declared: 'The object of the "SEVEN AND FIVE" is merely to express what they feel in terms that shall be intelligible, and not to demonstrate a theory nor to attack a tradition.'

This reassessment found its strongest expression in the depiction of the landscape, a potent symbol of national pride and identity. In the early twentieth century, however, the countryside was undergoing dramatic and rapid changes due to increasing industrialization and the cultivation of land for agricultural purposes. As Britain's population soared, so too did suburban sprawl, and new rail and road networks brought villages into closer contact with towns. In 1905 the commentator G. F. Masterman wrote: 'The Motor is indeed the keynote of the newer changes. All these June Sundays a procession of wandering locomotives hustles along the roads and avenues. The air is vocal with their hooting and shrill cries, the ritual of the New Religion, as they clank and crash through the village, leaving behind the moment's impression of the begoggled occupants, an evil smell, a cloud of grey dust.' By the mid-1930s, over 300,000 new cars were being registered each year.

In the face of this change two debates raged, one rejecting any form of progress and the preservation of rural tradition whilst the other promoted controlled development and access to the countryside. The Rural Industries Board was formed in 1921 to preserve traditional country crafts and the Council for the Preservation of Rural England in 1926 to prevent the type of indiscriminate development that had taken place in the aftermath of the war. However, campaigns such as the 'You can be sure of Shell' posters and the popular Shell guides, with contributors such as John Betjeman, John and Paul Nash and John Piper, encouraged people to motor to British heritage sites. Likewise, the Crown Film Unit and the General Post Office Film Unit produced films celebrating British traditions.

A similar divide can be seen in artists' depiction of the English countryside. In general, artists rejected the notion of progress and were selective in their portrayal of a rural idyll that was far removed from the beaten track. They retreated to areas that remained untouched by development, such as Ben and Winifred Nicholson's house in Cumberland or the community that Eric Gill established at Capel-y-ffin in the Welsh Black Mountains after leaving Ditchling in West Sussex. Others, at a time when foreign travel was increasing, journeyed to the Mediterranean and beyond to discover unchartered and unspoilt landscapes. Christopher Wood and Matthew Smith both found inspiration in France, and David Bomberg went to Palestine, where the sun-bleached landscape had an immediate impact on his art. However, other artists, such as David Jones and Eric Ravilious, began to paint a more realist landscape. Jones painted the suburbs of Brockley, and although Ravilious and his friend Edward Bawden bought a house in the Essex countryside to escape London, Ravilious often depicted the back gardens and greenhouses of middle-class England.

It is perhaps Paul Nash who, in his landscapes, best expresses the issues preoccupying post-war Britain. As an official war artist commissioned to document the battlefields of the Western Front during World War I, Nash used the ravaged landscapes of northern France as a conduit to channel his emotional response to the bloodshed, as in *We are Making a New World* (1918). His experience recording the aftermath of the Battle of Passchendaele transformed Nash from a romantic pastoralist to an artist who imbued the landscape with a deeper meaning. In his contribution to the progressive art group Unit One's publication of 1934, Nash attempted to identify the defining characteristics of English art: 'If I were asked to describe this spirit I would say it is of the land; *genius loci* is indeed almost its conception. If its expression could be designated I would say it is almost entirely lyrical.' This 'spirit of place' was perhaps the unifying factor in a period marked by individual styles and concerns.

Ethelbert White (1891–1972)
Wooded Landscape (Deer Pond) (n. d.)

Ink and wash on paper
45.5 x 32 cm
Presented by N. Wickham-Irving (1993)

White and his wife Betty were the personification of London's Bohemia in the early twentieth century, livening many a party with Ethelbert's guitar playing and Betty's spontaneous flamenco performances. Whilst enjoying the company of and exhibiting with fellow artists such as C. R. W. Nevinson, Edward Wadsworth and Percy Wyndham Lewis, the stalwarts of the artistic avant-garde, White experimented only briefly with a style akin to Vorticism.

White exhibited with the New English Art Club from 1912 and, in 1915, became a member of the London Group. His simple naïve style won him many admirers, among them the critic R. H. Wilenski who, in 1929, dubbed him a 'modern primitive'. However, White saw himself as essentially a pastoralist, working in the tradition of other English watercolourists, such as John Sell Cotman. White explained: 'I see the English countryside as an Englishman, and as an Englishman I try to paint it [...]. The criticism I most appreciate comes from the men who live on the land. When a picture pleases a tongue-tied farmhand, I know the artist has not gone far wrong [...]. For myself I try to get down to the big simplicities which live and breathe in the eternal mysteries.'

Eric Ravilious (1903–42)
New Bungalow (verso *The Back Garden at Bardfield*) (*c.* 1930)

Watercolour and pencil on paper
38.5 x 48.2 cm
Hussey Bequest, Chichester District
Council (1985)

Ravilious had met Edward Bawden at the Royal College of Art, where they studied from 1922. In 1929 they both decided that they needed to escape city life and find a permanent base from where they could paint their beloved English countryside. Taking their bicycles on the train, they left for Essex and stumbled across Brick House in Great Bardfield, which they immediately decided to rent. Tirzah Garwood, Ravilious's wife, remembered: 'The garden and country round Bardfield inspired them both and they competed with one another in conditions of various hardships, such as the ghastly weather, or working with the sun bang in their eyes […]. Bawden thought you ought to finish the painting on the spot, but Eric might do half his at home. They always worked very hard and got up very early in the morning.'

The reverse of this watercolour shows a pencil sketch of the garden of Brick House that Bawden had planted himself. This image of a bungalow under construction is typical of Ravilious's work in that, despite his love for the unspoilt countryside, at the same time he took great delight in depicting the landscapes of suburbia and the cultivated world of the back garden.

David Bomberg (1890–1957)
The South East Corner, Jerusalem (1926)

Oil on canvas
51.1 x 66 cm
Wilson Gift, through the National Art
Collections Fund (2004)

In the early 1920s, Bomberg was facing a personal crisis. His experience in World War I had led him to re-examine his use of a Vorticist style in favour of a more organic approach that affirmed humanity's ability to survive the destructive force of the machine. In addition, he was feeling increasingly isolated from his friends and former community in the East End of London and, in 1922, eagerly responded to his friend Muirhead Bone's suggestion to find employment with the Zionist movement as an artist in Palestine.

In Jerusalem, Bomberg found 'a Russian toy city, punctuated by its red roofs, jewelled with the gildings of the Mosque spire – set against hills – patterned with walls encircling the Christian holy places – the horizontal lines accentuated by the perpendicular forms [of] the minarets'. Initially working in a topographic manner to suit his patrons, he later adapted elements of Vorticism to produce an architectonic style that was softened by a looser handling of paint and brushwork. On exhibition in London in 1928, his Palestine paintings were generally admired, although one critic, alarmed at the dramatic change in his work, asked, 'What happened to the wild trumpeter?'

David Bomberg (1890–1957)
Study for *The South East Corner,
Jerusalem* (1926)

Charcoal on paper
51.2 x 66 cm
Wilson Gift, through the National Art
Collections Fund (2004)

David Bomberg (1890–1957)
Study for *The South East Corner,
Jerusalem* (1926)

Charcoal and colour crayon on paper
51.2 x 66 cm
Wilson Gift, through the National Art
Collections Fund (2004)

David Jones (1895–1974)
July Change (1930)

Watercolour on paper
59.5 x 46.7 cm
Kearley Bequest, through the National
Art Collections Fund (1989)

Jones thought that his most successful period was between 1929 and 1932, the time at which this watercolour was painted. In his memoirs, he recalls that he painted 'in a kind of fierce concentration', and all the works of this period have an energy and lightness of touch. 'I don't care how static the subject is, but it must be fluid in some way or another,' he wrote.

This watercolour was made either at Pigotts, the farmhouse in Buckinghamshire where his mentor Eric Gill moved in 1928, or Rock Hall in Northumberland, the home of the patron Helen Sutherland. Jones preferred to work from indoors, painting out of a window and into the light: 'I always work from the window of a house if it is at all possible. I like looking out into the world from a reasonably sheltered position. I can't paint in the wind. I like the indoors-outdoors, contained but limitless feeling of windows and doors. A man should be in a house; a beast in a field, and all that. The rambling, familiar, south, walled, small, flower-beddedness of Pigotts and the space, park, north, serene, clear, silverness of Rock in Northumberland both did something.'

Paul Nash (1889–1946)
Wittenham (1935)

Watercolour on paper
29 x 39 cm
Hussey Bequest, Chichester District
Council (1985)

Although a founder member of the art group Unit One, Paul Nash's own artistic identity was always being pulled between his commitment to International Modernism and his affinity with the English landscape and the Romantic tradition. The inherent spirit of a place was integral to Nash's vision, and he returned to certain landscapes throughout his career, imbuing them with a symbolic quality. The site of an ancient British camp, Wittenham Clumps on the Downs in Berkshire is one such place, and Nash first visited it in 1908 when staying with his uncle, returning in 1912 to make his first drawings. The most poignant depictions of this landscape belong to the last years of his life when he painted the Clumps as part of a series celebrating the different phases of the moon and the cycle of nature.

In 1946 he wrote: 'Ever since I remember them the Clumps had meant something to me. I felt their importance long before I knew their history. They eclipsed the impression of all the early landscapes I knew. This, I am certain, was due almost entirely to their formal features rather than to any associated force […]. They were the pyramids of my small world.'

Christopher Wood (1901–30)
Lemons in a Blue Basket (1922)

Oil on canvas
44 x 62 cm
Hussey Bequest, Chichester District
Council (1985)

Wood, although more closely associated with the artistic community of St Ives, began his career in the sophisticated circles of Parisian high society. The tension between his ambitions as an artist and the demands of a hedonistic lifestyle, including an addiction to opium, devilled Wood throughout his life, eventually contributing to his premature death at the age of 29.

Whilst in Paris in 1921, Wood met his long-time companion, the Chilean diplomat Antonio de Gandarillas. Together they travelled throughout the Mediterranean, where Wood was introduced to Picasso and Cocteau, and began to experiment with a variety of artistic styles. In May 1922, in a letter to his mother from Sicily, Wood described a drawing of lemons; and his words apply to the painting *Lemons in a Blue Basket*: 'the tablecloth is all ruffled, crinkled and troubled with dark shadows and ups and downs which suggest to me the world that these lemons live in, everything that is going on around them. I expect you think all this is madness, but I have thought a good deal about still-life and I think it is a means of expressing one's thoughts in a delicate manner which everyone else can't quite understand.'

Matthew Smith (1879–1959)
Landscape, Near Cagnes (1935)

Oil on canvas
53 x 64 cm
Hussey Bequest, Chichester District
Council (1985)

France was Smith's spiritual home. He first settled there in 1908 and found particular inspiration in the work of French artists: Gauguin and the Pont-Aven School, Matisse with whom he briefly studied in 1911 and the French Romantic Delacroix. In 1933 he first visited Cagnes-sur-Mer in the south , which had been the winter home of Renoir. Like him, Smith delighted in the fecund landscape, and he started to paint canvases that are characterized by a fluid brush dragged wet across the surface at great speed and outlined in red. He remarked: 'Colour equals light; light equals space; and there is a rhythm that pulls us into them and into the worship of nature.'

During an exhibition of his French paintings in London in 1936, the critic Clive Bell commented that 'the exhibition bears witness unmistakably to a breath of liberation', and the *Daily Telegraph* called Smith the 'most exciting of British post-war painters'. Smith's work inspired other artists, and, at the 1953 retrospective of his work, the artist Francis Bacon declared that Smith was 'one of the very few English painters since Constable and Turner to be concerned with paint – that is, with attempting to make idea and technique inseparable'.

Going Modern
Britain and International Modernism

In 1932 Paul Nash wrote of the dilemma facing his contemporaries – whether it was possible to 'go modern' and still 'be British'. 'We are invaded by very strong foreign influences, we possess certain solid traditions,' he declared. 'Once more we find ourselves conscious of a renaissance abroad, and are curious and rather embarrassed by the event; at once anxious to participate and afraid to commit ourselves, wishing to be modern, but uncertain whether that can be consistent with being British.'

During the 1930s an artistic avant-garde developed in Britain, the leading figures of which were Barbara Hepworth, Henry Moore, Paul Nash, Ben Nicholson, John Piper and his wife, the writer Myfanwy Evans. This group, described by the critic and curator Herbert Read as a 'gentle nest of artists' living in Hampstead, shared ostensibly similar concerns: a desire to be modern that was closely linked to a utopian vision of a modernist society of cleanliness, clarity and good design, where art and life were completely interrelated. They were aware of and responding to artistic developments on the Continent. During a trip to Paris in 1932, Hepworth and Nicholson met Jean Arp, Constantin Brancusi, Jean Hélion, Alexander Calder, Pablo Picasso and Georges Braque, and the following year they were invited to join the Abstraction-Création group. Piper and Evans also visited Paris and in 1934 played host to Fernand Léger, Braque and Hélion, who encouraged Evans to found *AXIS*, a quarterly review of contemporary abstract painting and sculpture. This progressive review illustrated work from the Continent by artists such as Pablo Picasso, Piet Mondrian, Wassily Kandinsky, Arp, Joan Miró, Alberto Giacometti and Calder.

When, in 1933, Nash founded Unit One, a group that included Hepworth, Nicholson and Moore, as well as John Armstrong, John Bigge, Edward Burra, Tristram Hillier, Edward Wadsworth and the architects Colin Lucas and Wells Coates, it was with an eye to the continental avant-garde. In a letter to the *Times* he explained that it was 'to stand for the expression of a truly contemporary spirit, for that thing which is recognized as peculiarly of today in painting, sculpture and architecture'. During the 1920s there had been no British artists' groups or art schools to compare with those on the Continent. Only the Seven and Five Society, which had been highly conservative until after Nicholson became President in 1926, was in anyway dynamic. In 1934 it changed its name to the Seven and Five Abstract Group and in 1935 held an entirely abstract exhibition at the Zwemmer Gallery.

Unit One was an attempt to unify the British avant-garde, but it encapsulated the avant-garde's inherent divisions and differing tendencies. These were represented by the pure abstraction of artists such as Hepworth and Nicholson, and the Surrealist tendency of artists such as Burra and Armstrong. In 1936, as the 'Abstract and Concrete Exhibition' toured England, the spectacular 'International Surrealist Exhibition' opened in London, organized by the artist Roland Penrose and poet David Gasgoyne, with the help of a committee that included Moore, Nash and Read. As much a literary as an artistic movement, Surrealism was concerned with the superior 'reality' of the imagery produced by the Freudian unconscious, with its bizarre, disturbing and incongruous juxtapositions. However, some artists, such as Calder, Giacometti, Miró and Moore, had work in both exhibitions. In an article entitled 'Order Order!' Evans wrote: 'The battle has been pitched between abstract painting and sculpture and Surrealist painting and sculpture; but there it cannot flourish. It is a silly battle. There are too many painters who do not paint in the name of either (though they have been claimed by one of the two or by both).'

The two groups were, to some extent, unified by the much more real political conflicts and tensions that were growing in the 1930s. Artists from both camps joined the Allied Artists Association in aid of such causes as the republican forces fighting in the Spanish Civil War. In 1938 Picasso's *Guernica* was exhibited in London, demonstrating the power of modern art as a language for political protest. The 1930s also saw the arrival of a flood of refugees and émigrés from continental Europe in the face of persecution by totalitarian regimes. These included Naum Gabo, László Moholy-Nagy, Piet Mondrian, Oskar Kokoschka, the ceramicists Lucie Rie and Hans Coper and the architects Walter Gropius, Marcel Breuer, Serge Chermayeff and Erich Mendelsohn, who designed the iconic De la Warr Pavilion in Bexhill-on-Sea in East Sussex, which with its sleek lines, glass curves and white walls epitomized modernist architecture.

Ultimately, with the coming of the war, the utopian vision of society that prevailed during the 1930s would not be realized. Nash's dilemma was perhaps only reconciled later in the Neo-Romantic paintings of John Piper, in which Britain's romantic heritage was presented in a distinctly modern style, or the landscape-based abstraction of the St Ives artists. However, the modernist spirit remained a vital force in the post-war work of Hepworth and Nicholson, and was to receive belated recognition at the 1951 Festival of Britain.

Paul Nash (1889–1946)
Dead Spring (1929)

Oil on canvas
48.5 x 40 cm
Kearley Bequest, through the National
Art Collections Fund (1989)

Dead Spring was completed just after the death of Nash's father in February 1929. The withered potted plant on the windowsill of his Judd Street flat is set within a matrix of geometrical shapes, including a set-square and ruler, the tools of the draughtsman. It demonstrates Nash's love of contrast and odd juxtaposition, particularly the organic and the man-made. It has been suggested by the art historian Andrew Causey that the draughtsman's tools in this picture indicate a concept of the 'artist as geometer', who can gain some control over organic life.

Nash had seen an exhibition of Giorgio de Chirico's work at an exhibition in London the previous year, and this work, like the related painting *Lares* (1929–30, Tate) of a set-square placed before his fireplace, reveals something of the Surrealist concern for the uncanny juxtaposition of objects. Nash was behind the formation of the avant-garde artists' group Unit One in 1933, and in 1936 he helped organize the 'International Surrealist Exhibition'. Although approaching abstraction, Nash sought a form of representation midway between direct figuration and pure abstraction.

Percy Wyndham Lewis (1882–1957)
Figures in an Interior (1934)

Ink and watercolour on paper
21.7 x 25.4 cm
Kearley Bequest, through the National
Art Collections Fund (1989)

During the early 1930s, Wyndham Lewis turned his attention to the promotion of modernist domestic architecture and design in a series of articles that were published in *Time and Tide* and *Architectural Review*. Lewis was strongly opposed to bare modern interiors, perhaps decorated with a single strategically placed work of modern art on an expanse of white wall. He wrote scathingly: 'Mr Modern – or Miss Modern – possesses few books, and as to pictures, of them he or she possesses none at all, except, of course, Mr Paul Nash's *Wood on the Downs* […]. Is it not possible for the very intellect to smell too much of disinfectant, and for hygiene to become, there, too, a curse?'

The cubes and blocks making up the stark white interior in this image are strongly reminiscent of 1930s modernist architecture. In Lewis's view this type of design represented an impoverished form of utopianism that didn't allow for meaningful works of art. The robotic figures in this image, which recall the mannequins in Giorgio de Chirico's metaphysical paintings, appear to be in a state of religious worship. Indeed, in an article entitled 'Plain Home-Builder: Where is your Vorticist?', Lewis wrote of such design in religious terms, likening it to puritanical asceticism.

Pablo Picasso (1881–1973)
Femme nue assise et trois
têtes barbues
(Seated Nude and Three bearded Heads)
(January 1934)

Sugar-lift aquatint, scraper, drypoint,
etching and burin on copper on paper
13 x 17.9 cm
Hussey Bequest, Chichester District
Council (1985)

As a graphic artist Picasso ranks with
the greatest of the twentieth century,
one of his outstanding achievements
being the set of 100 engravings known
as the 'Vollard Suite', which was
produced for the dealer Ambroise
Vollard in the early 1930s. The Suite is
like a sketchbook, a record of the artist's
activity, in which the role of the artist is
explored. This work from the Suite
demonstrates remarkable technical
boldness, considering it was the first
sugar-lift aquatint attempted by the
artist after he was introduced to the
technique by the printer Roger
Lacourière in January 1934.

The voluptuous young woman sitting
cross-legged at the left of this engraving
is a silhouette of Picasso's mistress
Marie-Thérèse Walter. Much of Picasso's
highly autobiographical graphic output
at this time explored her image, both as
a symbol of fecundity and sexuality and
as his artistic muse. It is possible that
she is dreaming of these three images
of the same bearded man, each of which
bears a different expression. The bearded
man often appears in Picasso's art as his
artistic alter ego. It is more likely, as her
image is left untouched in comparison
with the highly worked heads, that she
is the dream of these bearded sculptors.

Glyn Philpot (1884–1937)
Negro in Profile (1934–35)

Oil on canvas
52.5 x 36.4 cm
Bequeathed by Mrs Rosemary Newgas
(2004)

During the 1920s Philpot was a highly successful figure in the British art establishment, celebrated for his portraits of society figures that included the likes of the Prime Minister Stanley Baldwin, the Duchess of Westminster, the opera singer Dame Nellie Melba, the ballet dancers Vaslav Nijinsky and Lydia Lopokova and the author Siegfried Sassoon. He also had a strong sensibility for the social outsider. This powerful portrait is of his West Indian manservant Henry Thomas, who had come from Jamaica as a stoker on a merchant vessel and missed his boat home. He was subsequently 'discovered' wandering in the National Gallery by Philpot's godson, the scenographer Oliver Messel, and introduced to the artist in 1929, presumably because of his good looks rather than his reliability and domestic skills, which were, by all accounts, limited.

Philpot became known for his sympathetic paintings of black male models, particularly after 1930 when he took a studio in Montparnasse, Paris, and changed to a much more modern idiom. His dramatic change of style caused headlines such as 'Glyn Philpot Goes Picasso!' This portrait embodies the stylized and flatter style of Philpot's work in the 1930s, which is often regarded as representative of Art Deco.

Paul Klee (1879–1940)
Bewölkung (Clouds) (1926)

Watercolour on paper
45.8 x 30 cm
Kearley Bequest, through the National
Art Collections Fund (1989)

This subtle image is one of the series of exquisitely sensitive line drawings that Klee created in 1926, while he was a teacher at the Bauhaus in Dessau. He was a popular and inspired teacher, basing his teachings on deeply held personal theories that sought to examine the work of art as a microcosm of the universe. The delicately incised ink lines of this work, drawn over a dark watercolour wash, evoke the cloud forms of the title. Klee asserted that the artist's role was to suggest, not define. His concept of Form-Denken (or 'form-thinking') held that the artist was capable of multiple experiences and his work of multiple expressions and interpretations.

Klee used line, not so much as a means of representation, but in a more abstract way, to express feelings and moods. He famously spoke of 'taking a line for a walk', seeing the line as a primary element of expression, of revealing universal underlying patterns. The calligraphic line of this work appears to have an organic life of its own and suggests the presence of structures underlying the immediate reality that can be seen. It reflects Klee's view that, 'Art does not reproduce the visible, but makes visible.'

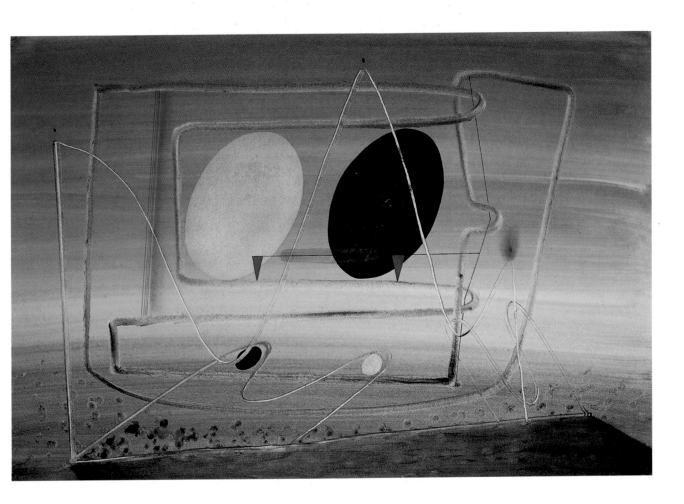

John Tunnard (1900–71)
Abstraction at Noon (1941)

Watercolour and gouache on paper
37.1 x 54.5 cm
Kearley Bequest, through the National
Art Collections Fund (1989)

Tunnard moved to Cornwall in 1930 to run a hand-blocked printed-silk business with his wife. During the 1930s he became an abstract artist, influenced by Surrealism and the work of Paul Klee and Joan Miró. His gouaches, a poetic fusion of the Constructivist and Surrealist tendencies in art, were, in the words of the collector Peggy Guggenheim, 'as musical as Kandinsky's, as delicate as Klee's, and as gay as Miró's'. The critic Herbert Read wrote of the 'cosmic overtones' and archetypal forms in Tunnard's work.

In *Abstraction at Noon* the inspiration is both technological and organic. The contrasting egg-like forms are suspended within a web of thread-like lines, recalling the constructions of Naum Gabo, who had moved to Cornwall in 1939. The rhythm and mobility of the lines can also be seen to reflect Tunnard's love of jazz music. They form an inner landscape, 'a dream of a future desert', for while there is the suggestion of infinite space, the semi-transparent structure would seem to have created an illogical shadow in the foreground. During the war years Tunnard served as an auxiliary coastguard, gazing out at expanses of sea that were broken up only by ships and hovering aircraft.

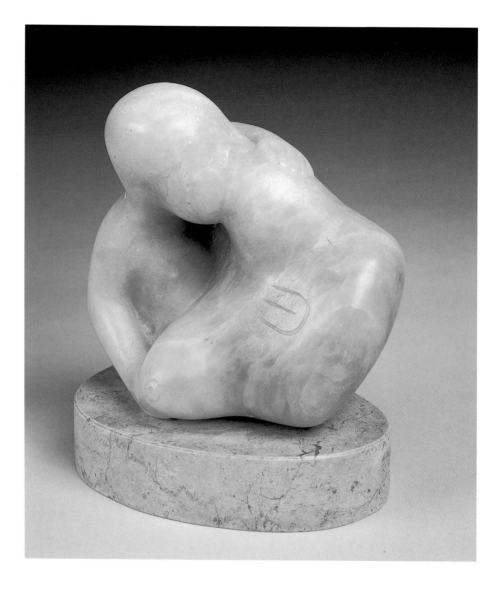

Henry Moore (1898–1986)
Suckling Child (1930)

Alabaster sculpture
19.5 x 19.5 x 13 cm
Hussey Bequest, Chichester District
Council (1985)

The mother and child was an enduring subject in Moore's work, to which he was to return repeatedly during his career. In this tender alabaster, the mother is represented by her breast alone, which the child is suckling and clutching with both hands. Instead of being a 'fragment', the breast is an organic form in itself. Moore often drew analogies between the reclining female figure and hilly landscapes. He had begun to carve reclining figures in stone between 1929 and 1930, after seeing a photograph of an ancient Mexican 'Chacmool' carving.

This sculpture is one of Moore's earliest organic abstractions. It was bought from his first one-man exhibition at the Leicester Galleries in 1931 by the sculptor Jacob Epstein. Its compact form and finish demonstrates Moore's ideas about 'retaining the sense of the block'. After reading Roger Fry's essay on 'Negro Sculpture' he had become aware of the doctrine of 'truth to materials', and during the 1930s he was a vocal exponent of it. Moore claimed: 'Every material has its own individual qualities. It is only when the sculptor works direct, when there is an active relationship with his material, that the material can take its part in the shaping of the idea.'

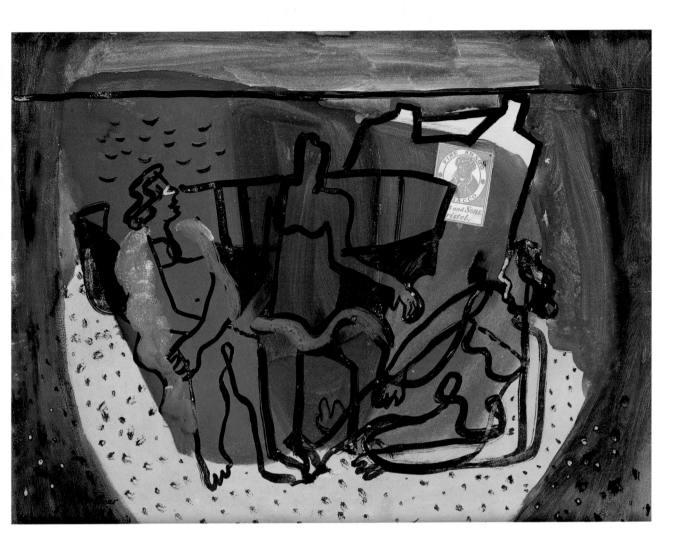

John Piper (1903–92)
Three Bathers beside the Sea (1934)

Gouache and collage on paper
38 x 51 cm
Accepted by HM Government in lieu of
inheritance tax and allocated to Pallant
House Gallery. Katherine Duff-West
Bequest (2003)

During the 1930s, Piper was at the
forefront of the modernist movement
in Britain, as art critic for *The Listener*
and *The Nation* and as a member of the
London Group and the Seven and Five
Society. He also worked closely with
the writer Myfanwy Evans, who was
later to become his wife, on the avant-
garde quarterly *AXIS*, which was
launched in 1935.

At this time he created a series of
artworks depicting the coastline of
southern England, inspired in part by
Georges Braque's Dieppe paintings of
1929, which he had seen in reproduction
in the magazine *Cahiers d'art*. Piper
was keen to find a modern style and

move closer to the abstractions of his
contemporaries in the Seven and Five.
In this picture, which is painted in a
faux-naïf, seemingly primitive, style, the
bathers, boat and horizon are reduced
to thick brushed lines. Their simplified
outlines recall the string pictures of
Jean Arp and the wire constructions of
Alexander Calder, whom Piper had met
during a trip to Paris in 1934. The
collaged label from a tobacco packet
suggests the sign on a seaside inn,
bringing an element of exterior 'reality'
to the image, in which topographical
interest is subordinated within an
almost abstract design.

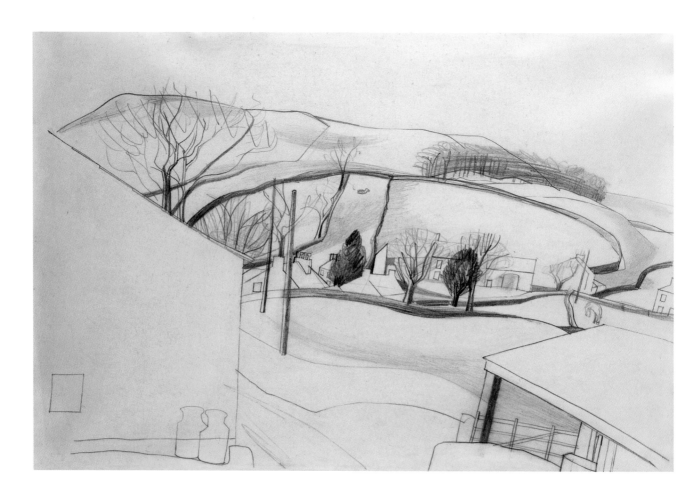

Ben Nicholson (1894–1982)
January 4 1953 (Thorpe, Wharfedale in snow)

Oil wash and pencil on paper
36.7 x 55.5 cm
Hussey Bequest, Chichester District
Council (1985)

Drawing was an important aspect of Nicholson's working methods as a means of investigating form. He frequently made drawings of the rooftops of the Cornish town of St Ives, where he lived from 1939 to 1958, attracted to the cubistic arrangement of shapes. He also enjoyed drawing buildings and ruins during his travels, concentrating on the relationship between buildings and the landscape. This carefully balanced drawing of the view from an upstairs window across the snow-covered village of Thorpe in the Yorkshire Dales was executed in January 1953, when Nicholson was staying with the abstract artist Cyril Reddihough.

Nicholson had a fundamentally linear approach to drawing, using the pencil in an analogous way to the chisel in his carved reliefs, to suggest volume and modelling without the aid of shading. His line has a controlled economy, subtly emphasizing the contrast between the angularity of the architecture and the natural curves of the hills, while maintaining an underlying structure. From the late 1940s, Nicholson would often apply a light wash of oil colour to the paper, preparing a number of sheets with oil washes of varying colour and opacity in advance and then selecting the one most suitable for the subject he wished to draw.

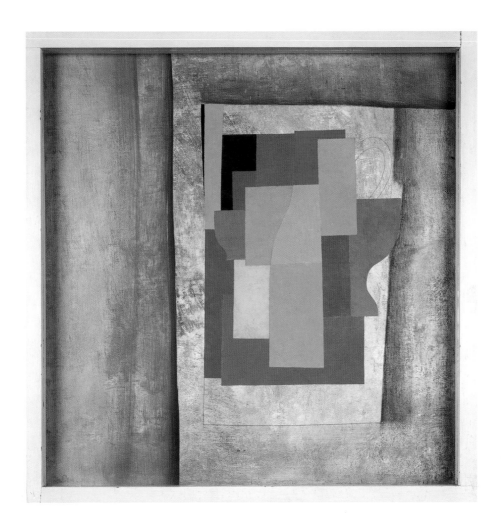

Ben Nicholson (1894–1982)
1946 (still life – cerulean)

Oil on canvas
64 x 63 cm
Kearley Bequest, through the National
Art Collections Fund (1989)

During the 1930s, Nicholson produced an iconic series of white reliefs, which were emblematic of the ideas of purity and order of the Modern Movement. In the immediate post-war years, colour and form were the subjects of his art and the impetus for a series of abstract, cubistic, tabletop still lifes, which were strongly influenced by the synthetic cubism of Juan Gris. In *1946 (still life – cerulean)* the opaque colours of the densely clustered objects contrast with the stone-grey ground to create a sense of space, despite the flattening of foreground objects and background.

These sharp-edged colours, including the sky-blue 'cerulean' of the title, appear to be collaged rather than painted.

'In painting a "still-life" one takes the simple every-day forms of a bottle-mug-jug-plate-on-table as the basis for the expression of an idea,' wrote Nicholson in his *Notes on 'Abstract' Art* (1948). 'The forms are not entirely free though they are free to the extent that each object can be seen from as many viewpoints as you wish at one and the same time, but the colours are free: bottle colour for plate, plate-colour for table, or just as you wish.'

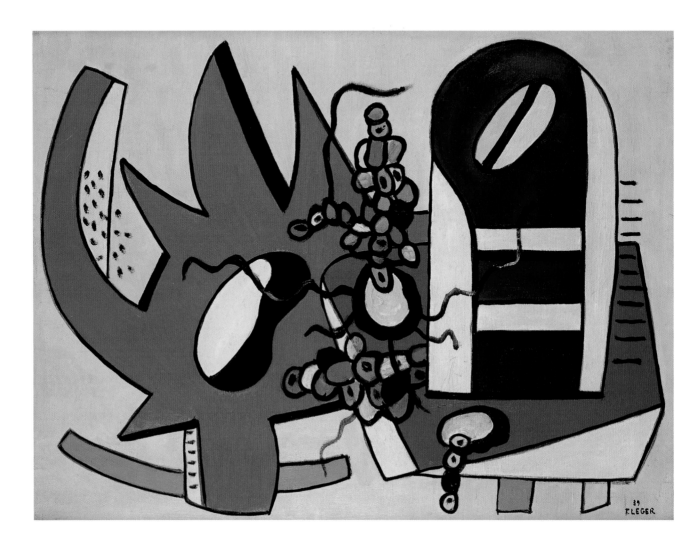

Fernand Léger (1881–1955)
L'Engrenage rouge (Nature morte en rouge et bleu)
The Red Gear (Still Life in Red and Blue)
(1939)

Oil on canvas
49.2 x 64.2 cm
Kearley Bequest, through the National
Art Collections Fund (1989)

In this bold painting Léger uses the traditional still-life format as a vehicle to explore form, colour and shape. These elements are explicitly the subject of the painting and given equal emphasis. 'It has never been a matter, in a work of art, of copying nature,' wrote Léger in 1933. 'It is a matter of finding an equivalent for nature, that is, capturing simultaneously within the frame life, movement and a harmony created by assembling lines, colours, and forms, independent of representation.'

Léger was interested in what he called 'the spectacle of objects' – new modes of aesthetic experience, which

he believed corresponded to the proliferation of mass-produced objects within the human environment. His interest in the contrast of constructive forces, between the naturally and mechanically produced, is expressed through the motifs of the active red 'gear', a plant form and passive blue jug on a table. These appear in a number of works by Léger from the late 1930s, most notably the mural he executed in Nelson A. Rockefeller's apartment in New York in 1938–39. The dynamic relationship between the forms is emphasized by the incisive outlines and flat, unmixed colour of the forms.

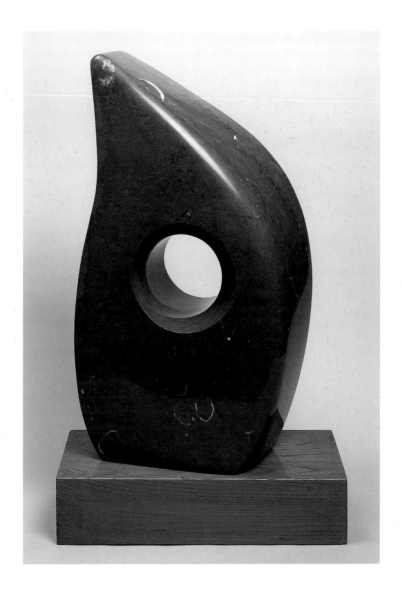

Barbara Hepworth (1903–75)
Single Form (Nocturne) (1968)

Irish black marble
67 x 35 x 14 cm
Hussey Bequest, Chichester District
Council (1985)

From the 1930s onward Hepworth created sculptures existing of a single upright form, which often suggest a relationship with the human figure. Her single-form sculptures have a mythical aura about them and often prompted comparison with standing stones and the Neolithic menhirs of Cornwall. *Single Form (Nocturne)* has echoes of the sculpture she created in 1964 for the United Nations headquarters in New York, as a memorial to Dag Hammarskjöld, the Secretary-General. Its gentle shape and simplicity is underpinned by the relationship between the form of the sculpture and the material from which it was made.

Hepworth created this sculpture following a conversation with Walter Hussey about what he looked for in a sculpture. She viewed piercing through the centre of a stone as a 'fusion of experience and myth'. These circular cavities not only recall the ancient Men-a-Tol sculptures in Cornwall, but are also explorations of space and form. Hepworth found a pleasure and freedom in piercing the solidity of the form. She claimed: 'Working in the abstract way seems to release one's personality and sharpen the perceptions so that in the observations of humanity or landscape it is the wholeness of inner intention which moves so profoundly.'

Jack Butler Yeats (1871–1957)
The Ox Mountains (1944)

Oil on board
23.4 x 36.7 cm
Kearley Bequest, through the National
Art Collections Fund (1989)

The Ox Mountains form a semicircle around Sligo, the town in the northwest of Ireland where Yeats grew up. He is the best-known Irish painter of the twentieth century, the son of the portrait painter John Butler Yeats and brother of the celebrated poet William Butler Yeats. As a painter he was drawn to the area's continually shifting light and shade, and the changes in quality of atmosphere, which he captured with extremely loose brushwork.

As a fervent Irish nationalist, Yeats found emotive sources of inspiration for his art in the landscape, history and mythology of Ireland – the Yeats brothers thought of County Sligo as the 'Land of Heart's Desire'. The indigo of the hills is typical of his palette in the 1940s. His early work as a painter was influenced by the French Impressionist pictures that he had seen in the collection of the Irish dealer Hugh Lane, but from the mid-1920s he developed a highly personal Expressionist technique, which bears a similarity to the work of Oskar Kokoschka, who became a great friend in the last decade of Yeat's life.

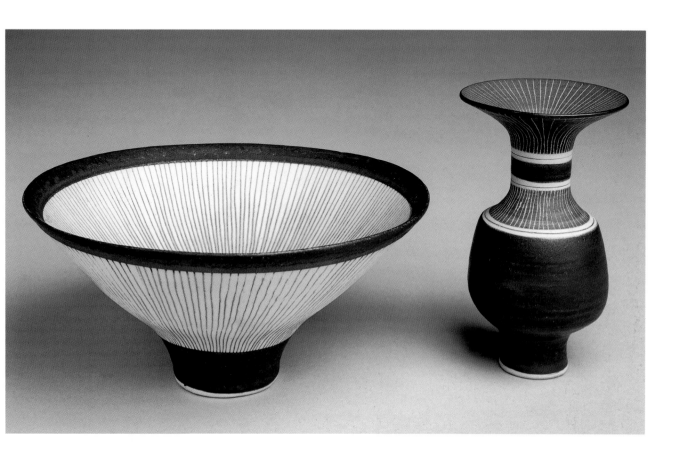

Lucie Rie (1902–85)
Bowl and *Bottle* (1980–81)

Porcelain (bronze, blue and white with
sgraffito and inlaid purple lines)
14.5 x 3.5 x 9 cm
9.5 x 5.5 x 20.5 cm
Hussey Bequest, Chichester District
Council (1985)

Rie's delicate ceramics, with their highly
individual approach to form and
decoration, bridge the divide between
the fine and applied arts. This footed
bowl and bottle-vase, with its tall, flared
neck shaped like a trumpet, are
decorated with *sgraffito* (scratching)
and incised lines inlaid with coloured
pigments that echo their shapes. Rie's
work has a distinctly European spirit of
modern design. Born in to an affluent
Austrian-Jewish family, she studied at
the famous Kunstgewerbeschule in
Vienna. On leaving art school in 1926
she married and began to achieve
success as a potter, winning Gold

Medals at both the Brussels
International Exhibition and the Milan
Triennale in the early 1930s.

Rie came to England in 1938, as a
refugee from Nazi persecution, leaving
behind her comfortable existence and
reputation. She found a garage in Albion
Mews, London, and divided her time
between working in a glass-button
workshop and making pottery in her
studio. After the war she reopened her
pottery, employing a number of people,
mostly fellow refugees such as Hans
Coper, to help her. She became one of
the leading British studio potters and
was to influence a generation of potters.

Devastation and Regeneration
The impact of World War II

In 1939, on the outbreak of war in Europe, Kenneth Clark, the Director of the National Gallery in London, set up a committee to investigate reviving the successful war-artists scheme of World War I. The outcome was the War Artists Advisory Committee (WAAC), administered by the Ministry of Information. The WAAC aimed 'to draw up a list of artists qualified to record the war at home and abroad [...] to advise on the selection of artists on this list for war purposes and on the arrangements for their employment.' The resulting works were shown in exhibitions at the National Gallery and also toured the country and abroad, acting as propaganda and boosting the morale of the British public. Clark intended that the scheme should not only help artists at a time of financial hardship, with the loss of commissions and teaching posts, but also provide a gainful alternative to being called up and the very real prospect of being killed in battle, although this was not to prevent three artists from losing their lives in the course of their work for the WAAC.

During World War I, artists such as David Bomberg, Percy Wyndham Lewis, Paul Nash and C. R. W. Nevinson, representing the artistic avant-garde, were elected as war artists and produced powerful images of conflict as a result. Their sometimes violent and perhaps incoherent imagery was, however, seen by some to contradict the intended roles of the war artist – issuing propaganda and documenting the war. With the lessons of the earlier scheme in mind, Clark's committee chose artists deemed appropriate for the task in hand. It stated: 'The War Artists collection cannot be completely representative of modern English art, because it cannot include those pure painters who are interested solely in putting down their feelings about shapes and colours, and not in facts, drama, and human emotions generally.' Clark later declared that the inclusion of Henry Moore and Graham Sutherland, who were both producing experimental work before the war, was 'the War Artists' Committee's boldest stroke'.

The artists involved in recording World War II were protected from the battlefield, and when they were commissioned to address the human dimension of war, this was more often than not the Home Front. The poet Stephen Spender wrote: 'The background to this war, corresponding to the Western Front in the last war, is the bombed city.' This is supported by John Piper's paintings of bomb-damaged buildings. However, both Piper's and Sutherland's paintings of bomb sites typically skirt the consequential loss of life, both artists being reluctant to intrude on others' private grief. Other images of the Home Front produced under this scheme included Moore's drawings of Underground shelters and miners working the coalface in Yorkshire and Sutherland's images of steel workers in Wales. Some artists were sent to record the conflict itself but from a comfortable distance, such as the illustrative watercolours of troops in North Africa and Italy by Edward Ardizzone. Possibly the only artists fully to capture the horror of World War II were the photographers, such as Lee Miller, who witnessed the liberation of the concentration camps in Eastern Europe.

The war had a major impact on the reputation and the work of artists commissioned by the WAAC. An article in *Good Housekeeping* called them 'apostles of the ordinary men and women of this country who stood up to it and took it, recorders of what German Kultur succeeded in doing to our buildings and failed to do to our soul'. Not only were they brought to the attention of the public, both at home and abroad, through the programme of exhibitions organized by the National Gallery, but the subject matter they were given, chosen with care by the committee to match the sensibilities of each artist, often influenced the course of their work after the war. Piper developed as a topographical artist who was to be forever associated with Britain's architectural heritage. The humanitarian approach Moore adopted in his treatment of people sheltering in the Underground was to find outlet in his sculptural series of the mother and child. Sutherland's later paintings of thorn bushes contain images redolent of the splintered and contorted ruins of the bomb-damaged building.

As in the aftermath of World War I, when artists returned to traditional means of representation and subject matter, so too did many in the late 1940s, trying to rekindle long-established values in the wake of unprecedented devastation and loss of life. Artists such as John Minton and other so-called Neo-Romantics depicted the landscape as a pastoral idyll, from their nostalgia for the England of William Blake and Samuel Palmer. Starved of contact with Europe, Ceri Richards and others turned to the Continent and, in particular, the work of Pablo Picasso and Henri Matisse. For Sutherland, the warm colours of southern France were to have a lasting impact on his work, and new vistas were opened up for Minton in the Mediterranean and later Jamaica. It was a time of nostalgia for a world that could never be reclaimed, but also a time for regeneration and renewal, when artists played a significant role in shaping a new Britain.

John Piper (1903–92)
Redland Park Congregational Church, Bristol (1940)

Oil on canvas
61 x 51 cm
Kearley Bequest, through the National Art Collections Fund (1989)

Piper was already an artist of some standing by the start of World War II, due to his association with the group of avant-garde artists experimenting with abstraction in the 1930s. His lifelong interest in architecture found new direction through the commissions he undertook on behalf of the WAAC and established his reputation as the foremost painter of Britain's architectural heritage.

At the end of 1940, Piper was commissioned to record bombed churches, initially in Coventry, where the cathedral had been destroyed in the air raids, and later in Bristol, Bath and London. Of these works, the poet John Betjeman wrote: 'When the bombs fell, when the city churches crashed, when the classic and Perpendicular glory of England was burnt and stark, he produced a series of oil paintings, using his theory of colour to keep the drama of a newly fallen bomb alive.' Piper's ability to seize on the essential architectural character of a building and to dramatise its destruction through the use of colour and simple shapes made him, in Kenneth Clark's words, 'the ideal recorder of bomb damage'.

Graham Sutherland (1903–81)
Devastation 1941 – City Panorama
(1941)

Ink, crayon and gouache on paper
31 x 45 cm
Hussey Bequest, Chichester District
Council (1985)

It was the exhibition of his painting *Camouflaged Bombers* of 1940 at the Leicester Galleries in London that prompted the WAAC to engage Sutherland as an official war artist in 1940. He was one of the few artists to be employed throughout the war, working on different projects until the end of hostilities in 1945.

Sutherland's first commission was to record bomb damage in and around Swansea, but in May 1941 he began a series of studies of the East End, bombed, as it transpired, in one of the last sustained assaults on London by the German *Luftwaffe*. Grouped under the title 'Devastation', these works show Sutherland was fascinated by how bombs had transformed the urban townscape: 'I became tremendously interested in parts of the East End where the shells of long terraces of houses remained; they were great – surprisingly wide – perspectives of destruction seeming to recede into infinity and the windowless blocks were like sight-less eyes.' As with other war artists, Sutherland was also acutely aware of his role as a detached observer of these scenes, behind which lay untold stories of human suffering.

Henry Moore (1898–1986)
Two Sleepers (1941)

Crayon, chalk and wash on paper
31 x 46.5 cm
Hussey Bequest, Chichester District
Council (1985)

Moore's sketches of people taking shelter in the London Underground during the Blitz, known through his 'Shelter Sketchbooks', started as a personal project. With his wife, Moore had encountered the Underground shelters when caught up in an air raid on his way back from central London, only a few days after the Blitz had started on 7 September 1940. He was greatly moved by this image of human suffering and the solidarity of the people grouped together in the tube network: 'We stayed there for an hour and I was fascinated by the sight of people camping out deep under the ground. I had never seen so many reclining figures and even the holes out of which the trains were coming seemed to me like the holes in my sculpture.'

Moore was persuaded to work his sketches up into finished drawings, which were then bought by the WAAC and exhibited with other commissions at the National Gallery, contributing greatly to Moore's popularity with the British public. Subsequently, Moore was commissioned by the committee to make a record of miners working the pits in Yorkshire.

Graham Sutherland (1903–81)
Thorn Head (1947)

Oil on canvas
40.9 x 40.9 cm
Hussey Bequest, Chichester District
Council (1985)

After he had been commissioned by Dean Walter Hussey to paint a Crucifixion for St Matthew's, Northampton, Sutherland began working on a series of paintings inspired by thorn bushes. These are similar to his earlier works where Sutherland exploits twisting tree roots and other organic forms to arrive at something that is far-removed from a conventional image of Nature. Painted following his trip to southern France, Sutherland has adopted a new, brighter palette to reflect the warmth of the Mediterranean climate.

Sutherland wrote: 'For the first time I started to notice thorn bushes, and the structure of thorns as they pierced the air. I made some drawings, and as I made them, a curious change developed. As the thorns rearranged themselves, they became, whilst still retaining their own pricking, space-encompassing life, something else – a kind of "stand-in" for a Crucifixion and a crucified head […]. The thorns sprang from the idea of potential cruelty – to me they were the cruelty: and I attempted to give the idea a double twist, as it were, by setting them in benign circumstances: blue skies, green grass, Crucifixions under warmth.'

Ceri Richards (1903–71)
The Rape of the Sabines (*Saudade*)
(1948)

Oil on canvas
98 x 142 cm
Hussey Bequest, Chichester District
Council (1985)

The theme of the rape of the Sabine
women, taken from Roman legend, was
a recurring subject in academic history
painting. The story of the abduction of
the women of the Sabine tribe by the
men of Rome in order to populate the
city presented a theme through which
Richards could further his interest in
representing the cycle of nature. The
theme of regeneration in the aftermath
of an act of violation also seemed
particularly apt in post-war Britain.

In 1946 Richards had read an essay
by Henri Matisse that described Paul
Cézanne's practice of drawing after the
Old Masters. In his many representations
of the subject, Richards has taken
elements from Rubens's version of the
Sabine legend hanging in the National
Gallery, as well as other paintings on
similar themes that he knew through
reproductions. In this version, as in
others, the moment of action also
resembles a dance. Richards had also
seen a reproduction of Matisse's *The
Dance* of 1909–10, and here he employs
the artist's same use of 'arabesques and
colour'. Walter Hussey bought the
painting in 1960 but renamed it *Saudade*,
perhaps after a dance performed by
Loie Fuller, considering the topic of rape
unsuitable for the Deanery walls.

Ivon Hitchens (1893–1979)
Flowers (1942)

Oil on canvas
61 x 56.3 cm
Mrs Diana King Bequest, through the
National Art Collections Fund (2003)

In this painting of flowers, it is possible to detect the mutual influence Hitchens shared with Winifred Nicholson. Hitchens stayed with the Nicholsons at their cottage at Banks Head in Cumberland in 1925, shortly after he had invited Ben Nicholson to become a member of the Seven and Five Society. There they began to 'relearn' how to paint, and, in their company, Hitchens began to use a more assured brush-stroke and bolder palette.

 Flowers was painted after the Hitchens's home and studio in Hampstead was damaged in August 1940 during the Blitz. Fortunately, Hitchens had already decamped – quite literally – with his wife and newly born son to the South Downs, where they were living in a gypsy caravan parked on six acres of woodland they had acquired near Petworth in West Sussex. A studio was built, and the caravan became their permanent home for the next few years, eventually being replaced as more rooms were added to the studio. Hitchens declared: 'One can read into a good flower picture the same problems that one faces with a landscape, near and far, meanings and movements of shapes and brush strokes. You keep playing with the object.'

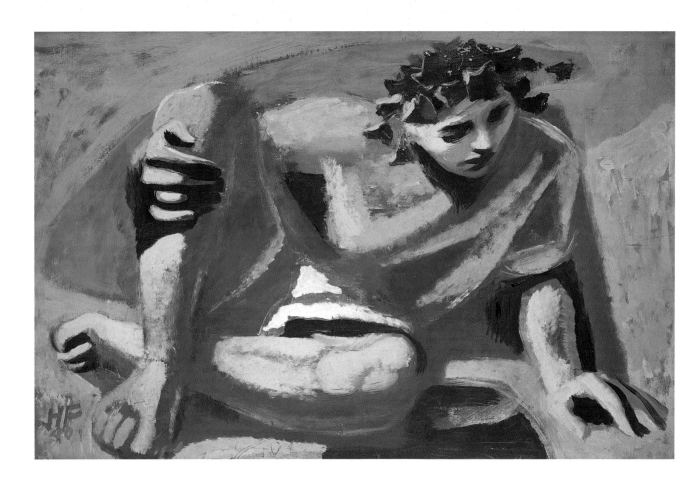

Hans Feibusch (1898–1998)
Narcissus (1946)

Oil on canvas
60.6 x 91.5 cm
Presented by the artist (1997)

It was not long after he had been awarded the prestigious German Grand State Prize for Painters by the Prussian Academy of Arts in Berlin in 1930 that Feibusch found his status as a Jewish artist was no longer tenable in the political and cultural climate of Hitler's Germany. Like many other artists and designers from central Europe, Feibusch left for England in 1933. He soon began to participate in London's cultural life, becoming a member of the London Group in 1935 and taking part in exhibitions organized by the Artists International Association. In Germany, his work was shown in the 'Degenerate

Art' exhibition of 1937, organized by the authorities to highlight the cultural ideology of the Nazi Party. As a Jewish artist, Feibusch's work was denigrated and destroyed.

Whilst many émigré artists shaped the development of abstract art and social realism in Britain in the 1930s, Feibusch's contribution was very particular in that he was to influence the art of mural painting. In *Narcissus*, it is possible to identify many of the qualities of his large-scale paintings in its bold use of colour and the strong modelling of the figure. This subject is typical of the introspection of much post-war art.

John Minton (1917–57)
Landscape near Kingston, Jamaica
(1950)

Ink and watercolour on paper
27.8 x 38.3 cm
Hussey Bequest, Chichester District
Council (1985)

In his earlier landscapes of pastoral idylls, Minton made his reputation as one of a group of artists being seen to further the Romantic tradition of English landscape painting. However, in 1950, acting almost on a whim, Minton decided to journey to the West Indies for the winter, where he encountered an altogether different landscape that was to inject his art with a new vigour and spirit. Writing for *Vogue* in 1951, he said: 'The colour of Jamaican landscape is that of coloured inks, of over-ripe fruit, acid lemon yellows, magentas, viridians, sharp like a discord. The vegetation, intricate, speckled and enormous, seems to grow before the eyes, bursting with sap, throttling itself in coils toward the sun.'

On his return, Minton made decorations for Soho's Colony Room and the Festival of Britain's Dome of Discovery that were influenced by his trip. His exhibition at the Lefevre Gallery in 1951 was acclaimed by critics, who recognized that Minton had captured the essence of Jamaica, one stating that he had 'fastened on the banana tree almost as tightly as Sutherland had clasped the more uncomfortable thorn-tree to his bosom'.

Graven Images
Church patronage in post-war Britain

The atrocities of World War II presented the Church of England, already shaken by the growing divide between culture and religious tradition, with an unprecedented spiritual crisis and challenged the clergy to find new ways of restoring faith and unity within its community. During the war Dr George Bell, Bishop of Chichester (1929–58), had been an outspoken defender of the rights of the individual over the totalitarianism of the state, whether in opposition to the persecution of the Jewish people in Nazi Germany or the British Government's retaliatory and indiscriminate bombing of German cities. He believed that culture was the key to re-establishing civilized values, and, addressing a conference in 1944, he urged: 'What we all need, what the world needs, is Order, a Pattern, a sense of purpose, a Philosophy, a Faith. The Church has a Faith, and the artist with his vision has the genius and the capacity to mediate Order and to represent that Faith.'

Bishop Bell began to commission contemporary artists to decorate churches in his diocese, including Hans Feibusch, an exiled German Jew who would paint a mural for St Wilfrid's Church in Brighton in 1939. Bishop Bell was also responsible for the more controversial murals by Duncan Grant and Vanessa Bell at Berwick Church, dedicated in 1943, where local people were used as models for the Holy Family, set in the Sussex countryside. Although hardly avant-garde artists, their use of a contemporary realist style was a slap in the face to those whose idea of ecclesiastical decoration was the insipid quasi-Victorianism that had been employed since the start of the century.

At the same time Walter Hussey, the Vicar of St Matthew's in Northampton (1938–55), was adopting a more radical approach to Church patronage of the arts. Initially, his interest was music, and in 1943 he commissioned compositions from both Benjamin Britten and Michael Tippett. In his choice of artists, Hussey was similarly forward thinking, wishing to commission works that were very much of their time, as opposed to the archaic realism of other contemporary religious art. He had been greatly impressed by Henry Moore's drawings of people taking shelter in the London Underground during the Blitz and, in 1944, asked him to sculpt a *Madonna and Child*. The finished work, considered at the time to be starkly modern in its treatment of an iconic image, invoked a tirade of adverse public commentary, although many critics applauded Hussey's vision. In 1949 Hussey's work at Northampton was to be given further publicity when Sir Alfred Munnings, in the last Presidential address he was to deliver at the Royal Academy, launched an attack against modern art, lambasting Pablo Picasso and Henri Matisse, and, at the same time, referring disparagingly to Moore's Madonna and Child as 'this graven image'. Hussey had also commissioned a painting of the Crucifixion by Graham Sutherland, and Munnings's comments fuelled a debate in the national papers as to the merits of both works and the role of modern art in the Church. The coverage ensured that Moore, Sutherland and Hussey were brought firmly to the public's attention.

There is no doubt that Hussey's commissions at Northampton influenced one of the most important post-war artistic projects – the reconstruction of Coventry Cathedral, which had been destroyed along with much of the city by German bombs in 1940. Basil Spence, the architect of the new cathedral, had seen and been moved by Sutherland's 'Crucifixion' in Northampton and, in 1951, commissioned him to design the huge tapestry *Christ in Glory in the Tetramorph* to hang on the wall behind the altar. When the cathedral was consecrated in 1962, the headlines proudly announced it as 'Britain's first space-age cathedral'.

In 1955 Bishop Bell recruited Hussey to become the new Dean of Chichester Cathedral. Hussey's first major project was to restore the Chapel of St Mary Magdalen, unveiled in 1961, for which Sutherland painted a canvas. Other commissions included an altar rail and candlesticks by Geoffrey Clarke, a set of copes designed by Ceri Richards, an altar frontal by Cecil Collins, the altar tapestry by John Piper and a stained-glass window by Marc Chagall, as well as music by Leonard Bernstein and William Walton. These artists were by now strongly established in the art world and represented a more conservative option, although works such as Piper's tapestry still managed to provoke strong local criticism. In the wake of projects such as Coventry, however, contemporary art in the Church was no longer the affront to public sensibilities it had once been considered. It remains to be seen whether, in the words of the art historian Kenneth Clark, 'we may have to wait a long time for a conjunction of aesthete, impresario and indomitable persuader that made Walter Hussey the last great patron of art in the Church of England'. Both Bishop Bell and Dean Hussey re-invented the tradition of commissioning contemporary artworks to serve as the mouthpiece of the Church, which is still being upheld in Chichester and elsewhere today.

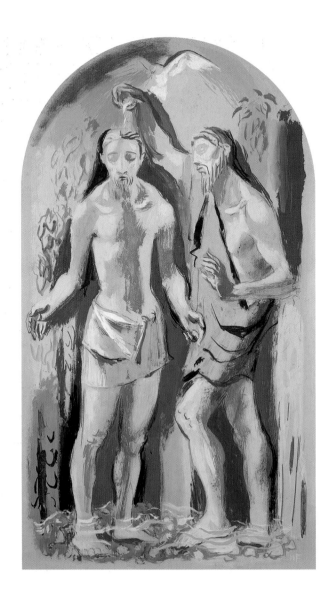

Hans Feibusch (1898–1998)
Baptism of Christ (1950–51)

Gouache on paper
71 x 41 cm
Presented by the artist (1997)

In the early 1920s, Feibusch had studied Italian Renaissance murals, but it was not until he and a group of fellow artists in Frankfurt were given a commission that he began to learn the techniques and procedures involved in mural painting. On his arrival in England, Feibusch executed small designs for private houses and was then given his first church commission for the Methodist Chapel in Colliers Wood, London. It was this mural that, in 1939, brought Feibusch to the attention of Dr George Bell, the Bishop of Chichester, and led to a number of commissions for the bishop's diocese, including that of the *Baptism of Christ* for Chichester Cathedral.

Feibusch's reputation steadily grew, and, through the murals he executed for bomb-damaged churches, he made a major artistic contribution to the reconstruction of post-war Britain. In his definitive book *Mural Painting*, published in 1946, Feibusch wrote: 'The men who came home from the war, and all the rest of us, have seen too much horror and evil […]. Only the most profound, tragic, moving, sublime vision can redeem us. The voice of the Church should be heard loud over the thunderstorm: and the artist should be her mouthpiece, as of old'.

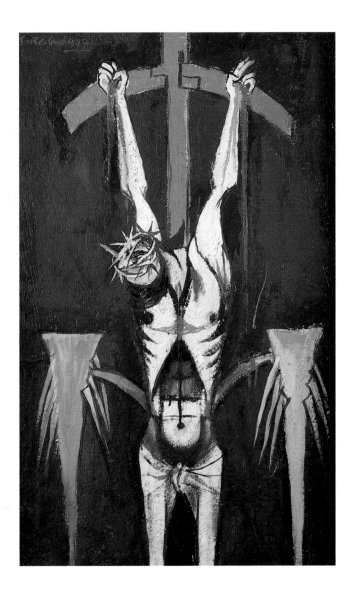

Graham Sutherland (1903–80)
The Crucifixion (1947)

Oil on board
67 x 41.3 cm
Hussey Bequest, Chichester District
Council (1985)

Walter Hussey first commissioned Sutherland in February 1944 when he asked him to paint a version of the 'Agony in the Garden' for the Church of St Matthew's in Northampton, where he was vicar. However, Sutherland chose instead to work on a version of the Crucifixion, and Hussey readily accepted this proposal.

Sutherland's composition was heavily influenced by a book he had seen of photographs taken of the concentration camps of Belsen, Auschwitz and Buchenwald. He wrote: 'These photographs were to have a great effect on me; I saw them just before I received a commission to paint a Crucifixion – in them many of the tortured bodies looked like figures deposed from crosses. The whole idea of the depiction of Christ crucified became much more real to me after having seen this book and it seemed to be possible to do this subject again. In any case the continuing beastliness and cruelty of mankind, amounting at times to madness, seems eternal and classic.' In all, he completed eight oil studies, all of varying size, design and background colour. This version is perhaps even more true to Sutherland's original concept than the final canvas in the rawness with which Christ's body has been portrayed.

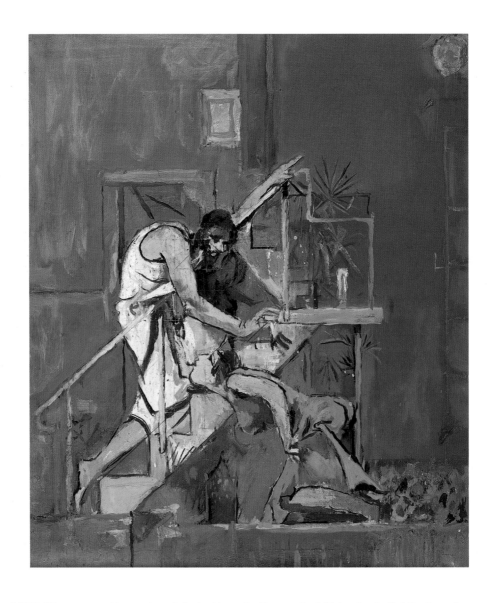

Graham Sutherland (1903–80)
Christ Appearing to Mary Magdalen
(*Noli Me Tangere*) (1961)

Oil on canvas
65.3 x 54.3 cm
Hussey Bequest, Chichester District
Council (1985)

Hussey chose Sutherland to work with him once again on a canvas for the newly restored Chapel of St Mary Magdalen in Chichester Cathedral. Hussey's choice of artists had been controversial at Northampton, but, in the aftermath of Coventry, acceptance of modern art in sacred places was growing. Although a member of the public damaged Sutherland's painting soon after it had been installed, on the whole it met with approval. On its unveiling, the critic Eric Newton wrote: 'That Graham Sutherland is almost the only living artist capable of expressing the full intensity of a Christian theme is now proved […]. To paint the Son of God momentarily mistaken for a gardener is surely more difficult than to visualise Christ crucified or Christ enthroned.'

In 1947 Sutherland made his first visit to the South of France, spending each year there and subsequently buying a house in Menton in 1955. This led him to use more brilliant colours in his work, which can be seen in the startling contrasts in this painting. Sutherland painted two versions of it, this one differing only slightly from the canvas now *in situ* in the cathedral.

John Piper (1903–92)
Study for *Chichester Cathedral Tapestry* (1965)

Gouache, crayon and ink on paper
58.2 x 77.8 cm
Accepted by HM Government in lieu of inheritance tax from the estate of John and Myfanwy Piper and allocated to Pallant House Gallery (2002)

Hussey knew of Piper's work through the cope designed by the artist that was presented to him on his retirement from St Matthew's. Initially, when confronted with the problem of how to enliven the altar area of Chichester Cathedral, Hussey had sought the advice of Henry Moore who had recommended Piper for the task. It was Piper who suggested the solution might lie in a brightly coloured tapestry. Later he would refer to it as 'in some ways the most frightening commission I have received'.

The design, showing the Holy Trinity flanked by the Elements and the Evangelists, met with considerable public reaction. It draws heavily on Piper's earlier abstract period, when he was at the forefront of the artistic avant-garde. Hussey wrote in his memoirs: 'There were perhaps more words of disapproval of the Tapestry than of anything else done at Chichester during my twenty-two years there. I think this was largely due to its prominent position; it couldn't be ignored, but drew the eye to that part of the cathedral, as indeed it was meant to do.' In 1967 Hussey also commissioned a set of festival vestments from Piper to complement the tapestry.

John Piper (1903–92)
The Head of Christ (n. d.)

Watercolour and gouache on paper
56 x 38.5 cm
Chichester District Council, purchased
with support of the V&A Purchase Grant
Fund (1985)

In 1935 Piper and his wife, Myfanwy
Evans, bought a second-hand car and,
armed with photographic equipment,
set off to document Early English
sculpture in Britain's churches. Piper felt
that Anglo-Saxon and Romanesque
sculpture was an art form that 'allowed
the artist or craftsman to work with the
whole of himself, and at the same time
to produce something that was, above
all, lucid and popular: not in the least
"highbrow"'. He found that parallels
could be drawn between Early English
art and contemporary art practice:
'Many a Picasso-like profile is to be
found on twelfth-century fonts and
capitals.'

The Romanesque reliefs in the south
aisle of Chichester Cathedral have been
a source of inspiration for many artists
in the twentieth century, including John
Craxton and Henry Moore, as well as
Piper. Moore said of them: 'They were
just what I wanted to emulate in
sculpture: the strength of directly
carved form, of hard stone, rather than
modelled flowing soft form.' Craxton
admired the expressive quality of the
simply carved features, particularly
those of Christ in *The Raising of Lazarus*.

Geoffrey Clarke (1924–)
God as the Centre of Nature (*c.*1952)

Forged and pierced iron
37.5 x 27.8 cm
Hussey Bequest, Chichester District
Council (1985)

In 1962, the same year that Coventry Cathedral was consecrated and Clarke produced three of its nave windows, he also completed important works in Chichester: a wall sculpture for the Bishop Otter College (now the University) and an altar rail and candle-sticks commissioned by Hussey for the cathedral. Although he had studied in the Stained Glass Department at the Royal College of Art in 1948, Clarke's interest was primarily in sculpture. The work he undertook was also fuelled by his background – his father was an architect and his grandfather a church furnisher – and the growth in post-war ecclesiastical and architectural commissions.

Inspired by Paul Klee's graphic work, Picasso's iron sculpture and an interest in primitivism that was stimulated by visits to the Natural History Museum, Clarke's early iron sculptures feature abstract forms and stylized figures. In 1956 the art historian Charles Spencer commented: 'In a somewhat unnerving manner, dramatic yet not theatrical, he has taken his imagery not from man's reflection, but from the natural structure of man and other living forms.' Clarke later became frustrated with working in iron as a medium for architectural commissions and turned instead to aluminium, for which he developed a particular casting technique.

Paths to Abstraction
Abstract art since World War II

In the years immediately following World War II, the leading abstract artists working in Britain were Barbara Hepworth and Ben Nicholson, whose art continued and developed the stylistic language of pre-war European Modernism. Hepworth and Nicholson became the pivot for a younger generation of abstract artists, who had gathered around the Cornish fishing town of St Ives, where the couple had moved at the outset of war with the Russian Constructivist sculptor Naum Gabo. These artists formed the 'St Ives School', which included Terry Frost, Patrick Heron, Roger Hilton and Peter Lanyon. Their art maintained a dialogue between abstraction and the landscape, translating their own sensations toward landscape into pure painting or sculpture, with forms and colours existing for their expressive sake. 'The picture is to be not primarily an image, but a space-creating mechanism,' asserted Hilton. 'A painter is a seeker after truth. Abstract art is the result of an attempt to make pictures more real, an attempt to come nearer to the essence of painting.'

The natural landscape was also a powerful stimulus for the paintings of Ivon Hitchens, who lived and worked near Petworth in Sussex. He had been particularly influenced by Wassily Kandinsky's writings on synaesthetic analogies between colour and music. Describing his paintings as 'visual sound,' Hitchens claimed, 'My pictures are painted to be listened to.' Ceri Richards similarly developed a form of abstraction that had its roots in the Welsh landscape and the music of Debussy, whose prelude *La Cathédrale engloutie*, inspired a series of lyrical paintings.

For many British artists, anxious to avoid provincialism, abstraction was seen as an international language that transcended the specifics of place. However, by 1950 'international' had increasingly come to signify 'American'. New York was perceived to have succeeded Paris as the international centre of abstract art. It was the home of the American Abstract Expressionists, who sought to create an art that expressed the universal psychological truths of human existence. Their gestural paintings, often on a vast scale, explored the notion of collective unconscious. During the Cold War, Abstract Expressionism was frequently linked to the notion of a 'free society' and seen to exemplify Western individualism and confidence, as opposed to the official realism of totalitarian states.

One of the first artists to come into contact with the innovations of the New York School was the Scottish artist Alan Davie, who encountered Jackson Pollock's paintings in Peggy Guggenheim's palazzo in Venice in 1948. Davie's paintings, which became increasingly vigorous and gestural, are rich in symbolic imagery derived from Eastern religion and his appreciation of Paul Klee and Pablo Picasso. During the 1950s, Davie, Frost, Heron, Lanyon and William Scott had a series of exhibitions in New York, where they met leading Abstract Expressionists such as Pollock, Mark Rothko and Franz Kline. The experience not only led Scott to increase the degree of abstraction and scale of his paintings but also confirmed, for him, his own distinct identity, the feeling that, 'there was a Europeanism that I belonged to'.

In 1953 American and European abstract artists were presented side by side for the first time in the exhibition 'Opposing Forces' at the ICA in London, which included Pollock, Sam Francis and Jean-Paul Riopelle. The spontaneous styles of Riopelle and Francis seemed to fuse the approach of the Americans with Surrealist automatic techniques. The first significant showing of Abstract Expressionism in Britain was in 1956 at the exhibition 'Modern Art in the United States' at the Tate, which included Pollock, Rothko, Kline, Robert Motherwell, Willem de Kooning and Barnett Newman. The size and vitality of their works made a great impression on British artists. Patrick Heron wrote: 'I was instantly elated by the size, energy, originality, economy, and inventive daring of many of the paintings. Their creative emptiness represented a radical discovery, I felt, as I did their flatness, or rather their spatial shallowness [...] we shall now watch New York as eagerly as Paris for new developments (not forgetting our own, let me add).'

In the 1960s a group of younger artists emerged, which included Gillian Ayres, Robyn Denny, John Hoyland, Paul Huxley, Mark Lancaster, Richard Smith and William Turnbull. The 'Situation' exhibitions of new British abstract art presented work that was 'without reference to the world outside the canvas' and dominated the spectator's field of vision through its scale. At the 'New Generation' exhibition, held at the Whitechapel Art Gallery in 1965, a sculptural equivalent to the new abstract painting appeared in the work of Anthony Caro, Tim Scott and William Tucker, which was characterized by complete abstraction, modern materials, bright colour and a new relationship with the spectator. This new relationship was also apparent in the Op Art of Bridget Riley, in which human visual perception was manipulated to affect the destruction of the picture surface by illusion.

Jean-Paul Riopelle (1922–2002)
Composition (1949)

Ink and watercolour on paper
55 x 74 cm
Kearley Bequest, through the National
Art Collections Fund (1989)

Born in Montreal, Riopelle spent most of his career in Paris but was considered the leading Canadian abstract painter of his generation. With Paul-Émile Borduas, Riopelle founded 'Les Automatistes', a radical group of Canadian abstract painters active in Montreal from 1946 to 1954. The group, so-named because of their interest in 'automatism', deriving from Surrealism, caused outrage with their anarchic manifesto *Refus Global (Total Refusal)*, which attacked various aspects of Canadian life and culture, including the Catholic Church. Riopelle settled in Paris in 1947, after visiting New York the previous year, and became acquainted with André Breton, Georges Mathieu, Joan Miró, Alberto Giacometti,

Antonin Artaud, Sam Francis and the writer Samuel Beckett.

Riopelle's spontaneous and calligraphic style owes as much to American Abstract Expressionism as to the automatic techniques of European Surrealism. His lyrical abstraction has been described as 'Tachiste' (from the French 'tache', a mark) because of the emphasis on the painted mark as an independently expressive element. 'There is neither abstraction nor representation: there is only expression, and to express oneself is to look at things and face them,' he claimed. 'To abstract means to remove, to isolate, to separate, while my aim, on the contrary, is to add, to draw near, to interrelate.'

Sam Francis (1923–94)
Composition (1957)

Gouache and watercolour on paper
77 x 56.5 cm
Kearley Bequest, through the National
Art Collections Fund (1989)

Composition is one of a group of paintings that the American artist Sam Francis created in 1957 after a visit to Japan, where the traditions of contemplative art had a powerful impact on his work, particularly the thin texture of his paint, his drip and splash technique and asymmetrical balance of colour against powerful voids. His approach has less to do with the American Abstract Expressionists, who would splash on pigments with abandon and with whom he exhibited, than with the controlled randomness of oriental calligraphy. Oriental art and Buddhist meditation helped Francis to understand the power of shape and to

colour and achieve a refined and delicate balance in his paintings.

The sense of ambiguous space derives from his application of pure colour in a liquid state; indeed he had claimed in 1954 that 'Space is colour'. Francis shifted the centre of gravity in his works, tending to leave the lower portions free, as if he were trying to release the colours into the air. The white area is an essential part of the composition, its emptiness according with the oriental notion of negative space. Francis was highly methodical and rigorous, while consciously creating running drip marks to give the appearance of spontaneity.

Ceri Richards (1903–71)
Cathédral engloutie (1960)

Oil on canvas
42 x 42 cm
Hussey Bequest, Chichester District
Council (1985)

Music and poetry were abiding influences for Richards's art. In 1960 he claimed: 'All artists – poets, musician, painters – are creating in their own idioms, metaphors for the nature of existence, for the secrets of their time.' From 1957 to 1962, Richards was preoccupied with a series of semi-abstract seascapes that were inspired by Claude Debussy's prelude *La Cathédrale engloutie*, an evocation of the legend of the submerged cathedral at Ys on the coast of Brittany, which was said to rise from the depths of the sea at moments of profound calm with its bells ringing through the water. The music

reminded him of the coast of Gower in Wales, where he had spent his youth, and he related the idea of the marine depths reclaiming a monumental human edifice to the notion of the 'cycle of nature'.

Richards sought to capture the lyrical mood of Debussy's music and illustrate its particular motifs, suggesting both the surface and far horizon with bold bands of terracotta, and rendering the depths of the sea, where the rose window of the cathedral is submerged, in a manner that recalls the Surrealist automatic technique of *frottage*.

Prunella Clough (1919–99)
Brown Wall (1964)

Oil on canvas
131.7 x 121.6 cm
Wilson Gift, through the National Art
Collections Fund (2004)

At first glance this painting, with its limited palette of earth colours, greys, blacks and ivory whites, appears to be a non-representational arrangement of forms and textures. However, Clough was a committed socialist, and this refined and sophisticated image is rooted in her gritty, urban subject matter. Clough developed a highly original and personal abstract language with which to distil the essence of transient urban and industrial spaces. Taking the particular and localized, and turning it into something large and generalized, she would create close-ups of her source material (building sites, industrial tips, machine parts and industrial wastelands), claiming, 'I like paintings that say a small thing edgily.'

Clough was the niece of the celebrated designer Eileen Gray and studied at the Chelsea School of Art, where her tutors included Graham Sutherland, Ceri Richards, Henry Moore, Robert Medley and Julian Trevelyan. After the war she became loosely associated with the Neo-Romantic artists and was close friends with Keith Vaughan, Robert Colquhoun and Robert MacBryde. In the post-war years her art increasingly excluded the figure to concentrate instead on the traces left by human activity, and to focus on the surface of the canvas.

William Scott (1913–89)
Blue Composition No. 1 (1966)

Gouache and watercolour on paper
50.8 x 62 cm
Hussey Bequest, Chichester District
Council (1985)

There is a simplicity and directness to Scott's pure abstract paintings. Flat lozenge-shaped forms with softened outlines float in an expanse of plain undifferentiated colour. The dark and mysterious forms contrast rhythmically against the blue ground, hanging in an indefinite space. Scott claimed: 'I find beauty in plainness, in a conception which is precise […]. A simple idea which to the observer in its intensity must inevitably shock and leave a concrete image in the mind.'

Scott was originally from Scotland, and, after studying at the Royal Academy, he lived in France during the late 1930s. He felt a close kinship with the still-life tradition of Jean-Baptiste-Siméon Chardin and Georges Braque, which led to a form of abstraction that developed out of their tradition. During the 1950s he made visits to New York and became friends with Jackson Pollock, Willem de Kooning, Mark Rothko and other American Abstract Expressionist painters. He admired the directness and immediacy of their colour field painting, but he remained European in spirit. 'I am an abstract artist in the sense that I abstract. I cannot be called non-figurative while I am still interested in the modern magic of space, primitive sex forms, the sensual and erotic, disconcerting contours, the things of life.'

Mark Lancaster (1938–)
Cambridge Red and Green (1968)

Liquitex on canvas
172.7 x 172.7 cm
Wilson Gift, through the National Art
Collections Fund (2004)

Originally from Yorkshire, Lancaster studied from 1961 to 1965 under Richard Hamilton at the University of Newcastle upon Tyne, where he also taught from 1965 to 1966. He first visited New York in 1964, where he worked briefly as an assistant to Andy Warhol in his Factory. Lancaster starred in a number of Warhol's films including *Kiss* (1964), in which he appeared with the poet Gerald Malanga, *Batman Drakula* (1964) and *Couch* (1964). The trip was to provide him with information and ideas that influenced his artist friends, including Stephen Buckley and Keith Milow.

Lancaster was one of the leading figures of the second generation of large-scale abstract painters that emerged in the Britain during the 1960s. His early paintings such as *Cambridge Red and Green*, which was produced during his residency at King's College, Cambridge, from 1968 to 1970, show the influence of American hard-edged abstraction, in particular Frank Stella's early paintings. In this painting, notions of colour are applied to a structure, which is divided by a grid. Lancaster placed rigorous emphasis on self-evident processes and overlapping patterns of paint application.

Ivon Hitchens (1893–1979)
Red Centre (1972)

Oil on canvas
59.8 x 72.5 cm
Kearley Bequest, through the National
Art Collections Fund (1989)

This exuberant painting was produced
in the last decade of Hitchen's life, when
his palette became increasingly vibrant.
Bright passages of colour are vigorously
applied in apparently spontaneous
brushstrokes. However, Hitchens planned
his compositions very deliberately,
according to formal principles. He
explained how 'a receding movement
demands a forward static movement,
just as academically one would admit
that a quantity of cool colour requires
some warm colour to oppose it to
preserve balance. This principle runs
throughout – dark-light, warm-cool, up-
down, in-out. Circular shapes, square

angular shapes. Large sombre areas –
short quick notes and so on. Thus all
the area of the canvas should be
consciously planned in movements.'

In the manner of Wassily Kandinsky,
Hitchens intended to create 'visual
sound' through patches and lines of
colour. 'My pictures are painted to be
"listened" to,' he asserted. 'I should like
things to fall into place with so clear a
notation that the spectator's eye and
"aesthetic ear" shall receive a clear
message, a clear tune. Every part should
be an inevitable part of the whole. I
seek to recreate the truth of nature by
making my own song about it (in paint).'

Alan Davie (1920–)
OM No. 10 (1972)

Gouache and watercolour on paper
59 x 83.2 cm
Kearley Bequest, through the National
Art Collections Fund (1989)

One of the first British artists to be
affected by Abstract Expressionism,
Davie initially studied at the Edinburgh
College of Art and briefly worked as a
professional jazz musician, before
spending a year travelling in Europe
between 1948 and 1949. On seeing
paintings by Jackson Pollock in Peggy
Guggenheim's collection in Venice, he
was inspired to paint on a larger scale in
a vigorous and improvisatory way.

Davie's eclectic style is rich with
symbolic and quasi-symbolic shapes
that suggest primitive magic rituals.
During the 1950s he became interested

in Zen Buddhism and African sculpture.
In 1971 he moved to the island of St
Lucia, and this introduced Caribbean
influences into his imagery. 'Basically
the creative state would appear to
amount to a kind of religious communion
with the GREAT ETERNAL,' he claimed.
'Here it is apparent to me that what I am
doing is fundamentally the same as
artists of remote times – the same as
artists in tribal society – engaged in a
shamanistic conjuring up of visions
which will link us metaphorically with
mysterious and spiritual forces normally
beyond our apprehension.'

Knowing Consumers
The Independent Group and the roots of Pop art

It was a sense of isolation in post-war Britain that led in 1948 to the foundation of the Institute of Contemporary Arts (ICA), by Peter Gregory, Roland Penrose, Herbert Read and Peter Watson and to the subsequent formation of the Independent Group. Read and Penrose had been leading voices of the pre-war avant-garde and, through the ICA, sought to promote European Modernism to the British public. In 1952 some younger members formed an unofficial discussion group that met at the ICA and was to include: the artists Richard Hamilton, Nigel Henderson, Eduardo Paolozzi and William Turnbull, who had met at the Slade School of Art, and John McHale, Magda and Frank Cordell; the architects Alison and Peter Smithson, Colin St John Wilson and James Stirling; and the writers Lawrence Alloway, Reyner Banham and Toni del Renzio. These artists, architects and thinkers, who became known as the Independent Group, took Modernism as the starting point of an analysis of culture. However, their enthusiasm for popular culture and technology set them apart from the elitist universalising aesthetic of the ICA's founders. They were anti-elitist and anti-academic, viewing culture not as a hierarchy, with 'fine art' at the top, but as a continuum between 'high' and 'low' culture.

Britain at this time was a place of austerity – rationing would not end completely until 1954. The group looked to America, developing a positive analysis of its mass-media imagery and celebrating the 'knowing consumer'. Their topics of discussion included science fiction, fashion, American advertising, helicopters, car design, popular music, westerns, architecture and action painting. At the first event Paolozzi showed his 'Bunk' collages of disparate images from sci-fi comics, magazines, car ads and animations – material that Alloway described as 'the modern flood of visual symbols'. Such mass-media imagery had not been taken seriously before. According to Colin St John Wilson, it was also 'the first time images had been shown – Blam, Blam, Blam – with no order or link'.

Their art often employed wit and humorous juxtaposition, glorifying the disorder of human existence. Much of it was influenced by Surrealist and Dadaist strategies. After the war Paolozzi and Turnbull had been resident in Paris and knew Alberto Giacometti, Fernand Léger, Jean Arp and Tristan Tzara, while Henderson also knew Max Ernst, Yves Tanguy and the group's hero, Marcel Duchamp. Their key texts were Amédée Ozenfant's *Foundations of Modern Art*, D'Arcy Wentworth Thompson's *On Growth and Form*, Siegfried Giedion's *Mechanisation Takes Command*, László Moholy-Nagy's *Vision in Motion* and Alexander Dorner's *The Way Beyond 'Art'*, each of which suggested new forms of perception and sources for art, as well as the idea that visual culture does not exist in a vacuum but in direct relation to science and technology.

The Independent Group made its most important statements through exhibitions. One of the most influential, 'Parallel of Life and Art,' was organized by Paolozzi, Henderson, Ronald Jenkins and the Smithsons in 1953. This ground-breaking exhibition sought to demonstrate the underlying unity of art and life, challenging the viewer's perception of what was beautiful and worthy of inclusion in a gallery. It was staged as a total environment, whereby photographic panels were suspended from the walls and ceilings: from photographs of paintings by Paul Klee and Jean Dubuffet, and of Jackson Pollock at work, to images of sci-fi monsters, aeroplanes, engines, benign tumours and rats. The aim of breaking down barriers between the artist, scientist and technician was shared by 'Man, Machine and Motion' – an exhibition organized by Hamilton and Banham in 1955. Its theme was 'a visual survey of man's relationship with the machinery of movement' and within a modular grid were displayed blown-up photographs of aerial, aquatic, interplanetary and terrestrial imagery – space-travel imagery on the ceiling, underwater imagery set on the floor and so on. The interaction of man and machine frequently appears as a theme in Hamilton's art, as in the iconic *Hers is a Lush Situation*.

The Independent Group officially disbanded in 1955, but the most important group manifestation of their ideas was the exhibition 'This is Tomorrow' at the Whitechapel Art Gallery, London, in 1956. Perhaps the most influential exhibition of the 1950s, it included 12 'environments', each of which were created by a group of artists and architects who shared interests and ideas. It aimed to overcome the separation between the disciplines of art and architecture through the notion of 'antagonistic co-operation'. The exhibit by Group 2 (Hamilton, McHale and John Voelcker) notably featured a 16-foot image of 'Robbie the Robot' from the movie *Forbidden Planet* and Marilyn Monroe on the subway grating from *The Seven Year Itch*, together with a reproduction of Van Gogh's *Sunflowers*, obscuring the distinction between popular and fine art.

The group's alternative concept of Modernism used culture in the widest sense as the source of art. It was this positive analysis and optimistic acceptance of popular culture that was of such crucial importance to the development of Pop art in the 1960s.

Eduardo Paolozzi (1924–)
Contemplative Object (Sculpture and Relief) c.1951 (cast 1952)

Bronze, from plaster cast
24 x 47 x 20 cm
Wilson Gift, through the National Art Collections Fund (2004)

Born in Edinburgh to Italian immigrants, Paolozzi attended the Slade School of Fine Art, before moving to Paris for two years in 1947, where he met Alberto Giacometti, Jean Dubuffet, Fernand Léger and the Dadaist Tristan Tzara. His early work fused his love of Surrealism with his interest in machine forms and mass-media imagery.

This extraordinary sculpture, with its biomorphic and animal-like connotations, is a study for a larger work in concrete. It featured in the 'Patio and Pavilion' installation by Paolozzi, Nigel Henderson and Alison and Peter Smithson for the exhibition 'This is Tomorrow'. The group sought to create a habitat that was

symbolic of human needs, according to their personal view of human existence. This sculpture was for contemplation. With its encrustation of knobs, mounds and textures, it is like a three-dimensional version of the relief collages that he was creating at this time. It looks forward to his later sculptures, in which the enrichment of the surface with found materials was a major concern and parallels his explorations of the human head. In the words of Diane Kirkpatrick, it 'resembles a strange horned toad […] one of the first pieces in which Paolozzi weds his image of a wonder-filled system-scape with a magical natural creature-presence'.

Eduardo Paolozzi (1924–)
Maquette for *The Unknown Political Prisoner* Competition (1952)

Plaster
43.2 x 61.2 x 35.6 cm
Wilson Gift, through the National Art Collections Fund (2004)

In January 1952 the ICA organized an international competition for a monument 'for all those men and women who in our time have given their lives or their liberty for the cause of human freedom', which was to be sited in West Berlin, on an area of raised ground overlooking the Russian sector. At a time of great political tension between the West and the Communist bloc, the competition became a catalyst for discussions about art as a tool for political propaganda, despite the fact that the ICA committee, which included Henry Moore, Roland Penrose and Herbert Read, was emphatic that its motives were apolitical.

Paolozzi's unrealized design took an ostensibly abstract approach, creating a group of closed architectonic forms that are incised with lines and patterns and arranged to exploit psychological space. These dolmen-like forms are distributed irregularly yet recall the magic sense of place of Stonehenge. Figures scratched on the 'buildings' are meant to serve as a scale module like the 'Modulor' figure that Le Corbusier incised into the concrete of a number of his apartment buildings. The smallest element, which is dwarfed by the larger blocks, is the prison tower, within which is the unseen political prisoner.

Nigel Henderson (1917–85)
Screen (1949–52 and 1960)

Photocollage on plywood
Four panels, each 152.4 x 50.8 cm
Wilson Gift, through the National Art
Collections Fund (2004)

Henderson had a passion for collecting ephemeral material such as cigarette cards, tobacco labels and newspaper cuttings. This remarkable collage forms both a commemoration of 1950s' mass-media imagery and a comprehensive record of Henderson's working practices and sources. With its pervasive sense of nostalgia it recalls a Victorian screen. However, the humour and irony of the juxtaposition of imagery and text, whereby Antonio Canova's *Three Graces* shares space with 1950s' pin-ups, and preference for signs and symbols within vernacular culture, makes it a direct forerunner of Pop art.

Henderson's mother had run the Guggenheim Jeune Gallery in London's Cork Street before the war, and through her he met Marcel Duchamp, Yves Tanguy and Max Ernst, whose Surrealist collages were to be a prime source of inspiration for his work. 'The found fragment, the *objet trouvé*, works like a talisman,' claimed Henderson. 'It feels as if it has dropped from outer space at the precise spot to intercept your passage and wink "its" message specifically at & for you [...]. I like the feeling of being "plugged in" to my universe; that it has signals laid for me like a paper chase (a cosmic nudge, a muffled snigger).'

Marcel Duchamp (1887–1968) and
Richard Hamilton (1922–)
The Oculist Witnesses (1967)

Mirror silver enclosed in
laminate plate glass
No. 4 of an edition of 50,
signed by both artists
63 x 46 cm
Wilson Gift, through the National Art
Collections Fund (2004)

Duchamp was a huge influence on
Hamilton and his contemporaries. In
1965 Hamilton began work on a new
version of one of Duchamp's most
famous works, a painting on glass
called *The Bride Stripped Bare by her
Bachelors, Even* (1915–23), also known
as *The Large Glass*, for a retrospective
of the artist's work. Its complex
scenario of sexual attraction and
frustration, using analogies drawn from
engineering and physics, was a source
of fascination to Hamilton. Hamilton
had previously created a typographic
version of Duchamp's *Green Box*, the
working notes for the original, between
1957 and 1960, which he used to
reconstruct the procedures involved.

The 'Oculist Witnesses' form an
element of the lower half of *The Large
Glass*. Duchamp was intrigued by
devices that play visual tricks, and in the
same way he was attracted to irony and
verbal puns. A *témoin oculaire*, in French
law, is an eyewitness; an *oculaire* is an
optician's eyepiece. The 'Oculist
Witnesses' are represented in the form
of an optician's eye-testing chart,
placed one above the other horizontally,
as a column of shimmering discs. They
play 'Peeping Tom', witnessing the
sexual frustration of the 'Bachelor
Apparatuses' who, in the words of
Hamilton, 'grind their own chocolate',
while the 'Bride' of the title 'hangs
stripped, yet inviolate in her glass cage.'

Nigel Henderson (1917–85)
Head of James Joyce (*c*.1960)

Collage and photographic processes on paper
45 x 33 cm
Wilson Gift, through the National Art Collections Fund (2004)

Henderson's images of the human head represent the culmination of his experimental photography, in particular what he referred to as his 'stressed' photographs, which were created by 'stretching and distorting the printing paper while enlarging in order to stress a point or evoke an atmosphere'. This photographic collage portrait of the head of James Joyce appears to be full of decay and atrophy. Henderson was familiar with Joyce's work through his mother's friendship with him as a publishing agent and had produced three posters for the exhibition 'James Joyce: His Life and Work' at the ICA in 1950.

Photographic fragments of landscape and other natural forms are seamlessly juxtaposed through collage followed by photomontage followed by collage. The disconcerting construction of a head from a collage of unrelated material recalls the paintings of the Renaissance artist Giuseppe Arcimboldo, who was celebrated by the Surrealists, and the work of Jean Dubuffet, in particular his image of a head made up of butterflies, *Cheveux de Sylvain* of 1953. It is closely related to Henderson's *Head of a Man* that was the centrepiece of the 'Patio and Pavilion' section of 'This is Tomorrow' in 1956.

Richard Hamilton (1922–)
Hers is a Lush Situation (1958)

Oil, cellulose, metal foil and collage
on panel
81 x 122 cm
Wilson Gift, through the National Art
Collections Fund (2004)

The review of a 1957 Buick in *Industrial Design* ended: 'The driver sits at the dead calm centre of all this motion; hers is a lush situation.' In this painting Hamilton explored the 'rhetoric of persuasion' written into car design, advertising and marketing, particularly the erotic play of idea and image between girls and machines. The synthesis of imagery and thematic motifs – Sophia Loren's collaged lips (a reference to the 'her' of the title), machine forms and the United Nations Building in New York (which, also collaged, doubles as a windscreen) – was inspired by Marcel Duchamp's *Green Box*. Hamilton's adoption of relief

reflects a new concept of space opened up by Cinemascope and 3-D projection, in which the image was thrust from the screen to meet its audience.

He commented: 'In slots between towering glass slabs writhes a sea of jostling metal, fabulously wrought like rocket and space probe, like lipstick sliding out of a lacquered brass sleeve, like waffle, like Jello. Passing UNO, NYC, NY, USA (point A), Sophia floats urbanely on waves of triple-dipped, infra-red-baked pressed steel. To her rear is left the stain of a prolonged breathy fart, the compounded exhaust of 300 brake horses.'

Richard Hamilton (1922–)
Interior Study (c) (c.1964)

Collage, oil and pastel on paper
38.1 x 50.8 cm
Wilson Loan (2004)

Hamilton's involvement with the domestic-interior theme began in the 1950s with the iconic collage *Just What Is It That Makes Today's Homes So Different, So Appealing?* In *Interior Study (c)* ready-made material from magazines is again used to create a sophisticated exploration of the language of visual signs. Hamilton had a fascination with publicity stills from films, and this bourgeois domestic interior, through which a young woman is striding, has a close relationship with the narrative strategies of the still. Hamilton explained his fascination with interiors: 'Any interior is a set of anachronisms, a museum, with the lingering residues of decorative styles that an inhabited space collects. Banal or beautiful, exquisite or sordid, each says a lot about its owner and something about humanity in general […] all tell a story and the narrative can be enthralling; some even give us a little lesson in art appreciation.'

Art is as much the subject as the interior. 'In the way that a human presence in a room will dominate the space with its strong psychological magnetism, a painting, or some other artistic manifestation will draw attention and command its environment,' Hamilton claimed. 'This occurs in a depicted room also, whether the treatment is highly stylized or not.'

Please Please Me
Art and popular culture in the 1960s and 1970s

In his letter of 1957 to fellow Independent Group members Alison and Peter Smithson, Richard Hamilton lists the characteristics of the source material he was using as the basis of his art in the late 1950s, but his description also serves as a definition of what was to become known as Pop art in the 1960s:

'Popular (designed for a mass audience)
Transient (short-term solution)
Expendable (easily forgotten)
Low cost
Mass produced
Young (aimed at youth)
Witty
Sexy
Gimmicky
Glamorous
Big Business.'

In Britain, Pop emerged from the Independent Group and, in particular, Eduardo Paolozzi, who set out to collect and preserve material from advertising and the mass media, believing it to be the subject for serious cultural investigation. His *Bunk* scrapbooks of collages, drawn from pulp-fiction magazines, pin-up books and *National Geographic*, evidence his desire to 'stress all that is wonderful or ambiguous in the most ordinary objects, in fact often in objects that nobody stops to look at or to admire'. A few years later, Peter Blake was beginning to reference popular culture in his paintings, and, as early as 1957, he was incorporating found objects and collage in his compositions. The body of work he produced in the late 1950s was to influence a generation of younger artists at the Royal College of Art.

The artist Colin Self cites a further reason for the emergence of Pop art in Britain: 'Mention might be made of the Left Wing standing of British Art Schools after World War II to keep up student numbers. They opened their door to the Working Classes (the War Babies) and Pop Art was, within a generation, what happened […]. Sociologically, there is something of a point here to make. Art Schools as "Working Class" hotbeds of "anarchy" and unbridled centres of creative expression. Pop came out of that.'

The artists that graduated from the Royal College of Art in the early 1960s, including Derek Boshier, Patrick Caulfield, David Hockney, Allen Jones, R. B. Kitaj and Peter Phillips, were immediately put on the public stage in a series of exhibitions entitled 'Young Contemporaries', held at the Royal Society of British Artists Galleries between 1961 and 1963, and also in the significant exhibition the 'New Generation', staged by art historian Bryan Robertson at the Whitechapel Gallery in 1964. Although not all allied themselves with the term 'Pop', these graduates exhibited a shared reaction against what they saw as the insular world of English art, personified by the St Ives artists; they embraced 'Swinging London' and all it stood for in their painting. Lawrence Alloway commented: 'For these artists the creative act is nourished on the urban environment they have always lived in.'

Another characteristic of Pop art was the use of non-traditional materials and techniques. Artists such as Caulfield began to work with household paint, not only because of its relative cheapness but also its potential to negate the 'artiness' of their art. 'My paintings were fairly raw,' said Caulfield. 'I used decorator's gloss paint on hardboard because I liked the impersonal surface they produced. I didn't like misty brush-strokes and atmospheric painting – this was my reaction against the Englishness of English painting which so greatly valued a slightly understated, tentative figuration.' The 1960s also saw artists using the commercial process of silkscreen printing for fine-art purposes for the first time. Kelpra Studios, run by Chris Prater, was particularly important in collaborative projects with Paolozzi, Kitaj and Caulfield that pushed the concept of the artist's print in innovative directions.

There has been much discussion as to the influence of the United States in the development of Pop art in Britain. There is no doubt that the work produced by American artists Jasper Johns and Robert Rauschenberg in the late 1950s was integral to the development of the style in both Britain and the United States. The exhibitions of American modern art in London in the 1950s had a huge impact on artists such as Caulfield and Howard Hodgkin. Also, in the context of post-war austerity in Britain, where rationing only ended in 1954, the influx of Americana was a seductive subject for British artists. However, the very nature of Pop art meant that it was the product of the particular cultural context of each country, and as such both American and British Pop developed independently yet in parallel with one another.

Peter Blake (1932–)
Girls with their Hero (1959–62)

Oil on hardboard
152.4 x 121.9 cm
Wilson Gift, through the National Art
Collections Fund (2003)

Blake's passion for American music, as for all Americana, developed early, a result of his discovering his father's collection of swing records, as well as evenings spent at the Dartford Rhythm Club from the age of 15. In the 1950s the United States was the epitome of cool, the very opposite of post-war Britain. Blake started collecting images of Elvis long before beginning this, the first of his pop-music paintings. It was his fascination with popular culture and the phenomenon of fandom that excited him, however, rather than Presley himself. Blake explained: 'I'm a fan of the legend rather than the person.'

Blake has used his graphic-design training at Gravesend Technical College and School of Art to represent Elvis through images from the mass media, fictionally collected by the 'real' girls in the painting. Later, in paintings such as *Got a Girl* (1960–61) and *El* (1961), he would use actual objects stuck to the painted picture surface. Blake's use of American icons in his art preceded that of Andy Warhol by several years, fuelling his resentment of American critics who panned an exhibition of British Pop in New York in 1962, dubbing it a second-class imitation of the American version.

Colin Self (1941–)
*Waiting Women and Nuclear Bomber
(Handley-Page Victors)* (1962–63)

Oil on board
112 x 183 cm
Wilson Gift, through the National Art
Collections Fund (2004)

For Self, it was important that Pop art should embrace twentieth-century iconography, describing it as 'the first movement for goodness knows how long, to accept and reflect the world in which it lives'. He wrote: 'Personally, for me, Pop Art represented being "understood", being "open". The antithesis of all that abstract, pseudo, complex "arty-farty art", dribble art.' This large painting represents the artist's viewpoint at a time when advances in

technology, combined with Cold War politics, made him apprehensive about the imminent annihilation of the planet. Self was one of the few self-proclaimed Pop artists to take an overtly political stance in his works.

Self was represented by Robert Fraser, the art dealer, and collected by Brian Jones of the Rolling Stones, but in 1965 he rejected the commercialism of the art world and left London to live permanently in Norwich.

R. B. Kitaj (1932–)
Specimen Musings of a Democrat (1961)

Oil and collage on canvas
102 x 127.5 cm
Wilson Gift, through the National Art
Collections Fund (2004)

Born in the United States, Kitaj came to Oxford in 1958 to attend the Ruskin School under the terms of the American GI Bill, which offered further training to ex-servicemen, and a year later he transferred to the Royal College of Art. He graduated at the same time as many of the key Pop artists and worked closely with Eduardo Paolozzi, thereby becoming associated with the movement. However, Kitaj allies himself with Surrealism rather than Pop, many of his works being composed out of 'free association' and relating to the subconscious. His paintings draw on complex sources from art, literature, history and politics, stemming from his collection of clippings from *Life* magazine and his encounter with the *Journal of the Warburg and Courtauld Institutes* at the Ashmolean Library. In this respect, his use of source material and the collage-like structure of his work can be related to Pop art.

This painting weaves Kitaj's interest in the Catalan philosopher Ramón Lull and the diagrammatic paintings of Rauschenberg with Kitaj's advocacy of socialist and anarchic politics. As the art historian Marco Livingstone has said of Kitaj's encoded works, 'In a way, all the evidence is there: it requires only an inquiring mind to begin to make some sense of it.'

R. B. Kitaj (1932–)
Priest, Deckchair and Distraught Woman
(1961)

Oil on canvas
127 x 101.6 cm
Wilson Gift, through the National Art
Collections Fund (2004)

This painting is again evidence of Kitaj's fascination with both the *Journal of the Warburg and Courtauld Institutes* and the idiosyncratic approach to aesthetic and cultural history of the art historian Aby Warburg. The figures of the priest and distraught woman both appear in Kitaj's earlier painting *Specimen Musings of a Democrat*, as indeed does the deckchair. Here, however, the distraught woman is given prominence as a reference to what Warburg referred to as the 'Nympha' or 'Maenad' in Florentine Renaissance art, which he described as an intrusive and incongruous figure. With her flowing garments and hair, 'Nympha' is similar to Botticelli's female figures, but Warburg was more concerned with her hidden cultural and socio-historical meanings than with her aesthetic qualities. In Kitaj's painting, the allusion to Warburg's 'Nympha' may be seen as an indication of Kitaj's own loaded approach to pictorial composition and as a testament to the diverse literary and historical sources he plundered for his complex works.

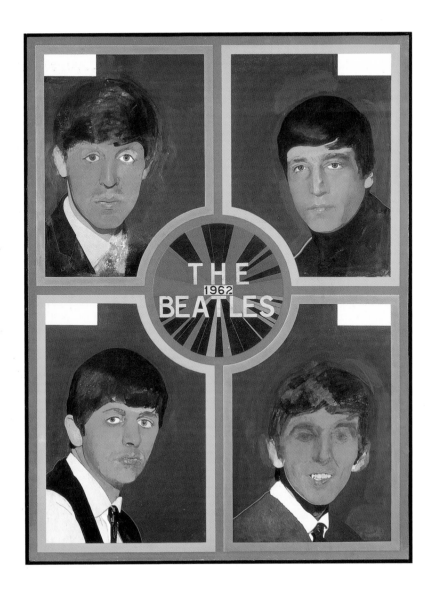

Peter Blake (1932–)
The Beatles 1962 (1963–68)

Acrylic emulsion on hardboard
121.9 x 91.4 cm
Wilson Gift, through the National Art
Collections Fund (2004)

Blake had met The Beatles in the early 1960s, before their acceleration to superstardom following the release of the No. 1 hit album *Please Please Me* in March 1963. In conversation with the critic Mervyn Levy, Blake rather quaintly said: 'At the moment I'm working on a large conversation piece of the Liverpool song group, The Beatles. Each of these chaps is closely associated with the city and I hope that the local Beatle fans will find in this picture a visual significance that will somehow match the mood of Beatle music.'

His portrait of The Beatles was part of a series based on pop musicians,

also including Bo Diddley and The Lettermen, that Blake embarked on after a trip to Los Angeles with his Californian wife, Jann Haworth, in November 1963. Blake has mimicked the idiosyncrasies of the printing process, including the coloured auras around the Fab Four's shoulders caused in print through mis-registration. He has also copied the design of record sleeves and fan magazines in his use of the 'fairground' central panel and coloured borders. The white boxes were intended to hold each band member's autograph, but sadly they were never signed.

Richard Hamilton (1922–)
Swingeing London '67 (1967–68)

Relief screenprint and oil on photo
on board
50.8 x 79.5 x 0.7 cm
Wilson Gift, through the National Art
Collections Fund (2004)

'JAGGER SPENDS NIGHT IN CELL. The prison doors clanged last night behind Mick Jagger, lead singer of the Rolling Stones. And ahead stretched a night in a Lewes jail cell for the long-haired pop idol of the teenagers […]. Jagger travelled the 37 miles to Lewes in a prison van with Fraser and four other men – and it was to teenage screams that he left Chichester.' So ran an article in the *Daily Express* on 28 June 1967, recounting the dramatic events behind the arrests at the home of Keith Richard, the lead guitarist of the Rolling Stones, at Redlands in West Sussex.

The art dealer Robert Fraser, one of those arrested, represented Richard

Hamilton, who created this artwork in protest at the so-called 'swingeing sentence' imposed on his friends. Commenting on the sensationalist and varying accounts of the arrests given in the press, Hamilton created six different versions of 'Swingeing London', each incorporating a screenprint taken from a *Daily Mail* photograph of Jagger and Fraser being driven to Chichester Magistrates Court. This version has a relief-moulded frame and glazed panel that simulates the police-van windows, and Hamilton has added paint and metallized acetate to highlight the hand-cuffs binding Jagger and Fraser together.

Joe Tilson (1928–)
1–5 (The Senses) (1963)

Mixed media
233 x 152.4 cm
Wilson Gift, through the National Art
Collections Fund (2004)

Before Tilson went to St Martin's School of Art in 1949, he had learnt carpentry and joinery skills at Brixton School of Building. In the late 1950s, following his studies at the Royal College of Art, where Peter Blake and Richard Smith were fellow students, Tilson began to make reliefs in wood, drawing on his early experience. These games-like structures involve words or emblematic imagery and represent the constructive impulse that Friedrich Froebel, the inventor of the kindergarten, recognized as being an important part of play. The link with childhood and the use of symbols in works like *1–5 (The Senses)* places Tilson's work within the Pop art aesthetic. However, the handmade look of the result affirms his rejection of technology and the consumer society that runs counter to the underlying ethos of Pop art. Tilson said of his work: 'I think of art as a tool of understanding, an instrument of transformation to put yourself in harmony with the world and [with] life […]. The basic given data of experience and the physiological and psychological aspects of procreation and birth are totally unchanged. What I'm dealing with is trying to pick up these very basic facts and propose them again as Art.'

Patrick Caulfield (1936–)
Portrait of Juan Gris (1963)

Alkyd housepaint on hardboard
122 x 122 cm
Wilson Gift, through the National Art
Collections Fund (2004)

Caulfield contributed four paintings to the 'New Generation' exhibition at the Whitechapel Art Gallery in 1964, including *Portrait of Juan Gris*, made in his last year at the Royal College of Art. The original sketches show that he had been working on a portrait of Paul Cézanne, who was lauded in art schools as the father of Modernism. However, he veered away from making an ironical comment about an art-school cliché to paying homage to the Spanish Cubist, whom he admired for the architectural and decorative qualities of his work.

Caulfield has taken angular forms used in Gris's early still lifes to outline objects and used these to frame the figure of the artist. Rather than help to translate three-dimensional forms on to a two-dimensional surface, here these devices serve to deny the illusion of space. Caulfield's use of commercial gloss paint on hardboard also emphasizes the flatness of the picture-plane. Writing to the critic Christopher Finch in 1969, Caulfield explained: 'The reasons I painted the picture in bright blue and yellow are that I see them as positive and optimistic colours which in some way reflect what I felt about Gris despite his own generally subdued palette, and that I enjoyed using such bright colours in contrast to his name "gris".'

Eduardo Paolozzi (1924–)
Wittgenstein in New York from
'As is When' (1965)

Screenprint, set of two folios of 12
prints, edition 30/65
80 x 55 cm
Wilson Gift, through the National Art
Collections Fund (2004)

The print portfolios of the sculptor
Eduardo Paolozzi brought him back into
the public eye and gave him the
dubious standing of a leading Pop artist,
although, like his contemporary R. B.
Kitaj, Paolozzi also insisted his roots lay
in Surrealism. He had a deep interest in
printed ephemera, stemming from his
experience in his parents' sweet shop in
Leith, Edinburgh. In 1952 he famously
displayed collages made from this
material at the ICA as part of a lecture
organized by the Independent Group. A
decade later, when collaborating with
Chris Prater of Kelpra Studios, Paolozzi
used these influences in innovative
colourful screenprints. As the architect
Colin St John Wilson has said, 'Paolozzi's
graphics originate as collage – he adds
to a background the most diverse
elements, quotations from reality and
abstract patterns, in a playfully
experimental order – until one stands out
as the one he has been searching for.'

The portfolio of prints 'As is When',
based on the life of the Austrian-born
British philosopher Wittgenstein, consists
of 12 screenprints, each with a unique
colour combination. Paolozzi was the
first to explore this device in print, four
years before Andy Warhol's serially
coloured prints of Marilyn Monroe.

Howard Hodgkin (1932–)
Grantchester Road (1975)

Oil on wood panel
124.5 x 145 cm
Wilson Loan (2004)

Hodgkin has cited the years he spent in New York as a refugee from wartime London as key to his development as a painter. It was there that he first saw works by European masters such as Henri Matisse, Pablo Picasso and Wassily Kandinsky. He also came under the influence of American artists, later to be cemented by his visit to the seminal exhibition 'The New American Painting' at the Tate Gallery in 1959. In contrast to his contemporaries associated with Pop art, Hodgkin's work in the 1960s dealt with intimate personal subjects, leading him to describe himself as 'a representational painter, but not a painter of appearances. I paint pictures of emotional situations'.

The critic Andrew Graham-Dixon has said of Hodgkin: 'His paintings exist at the margin between representation and abstraction, bright mosaics shot through with hints and suggestions and glimmerings of recognisable form.' In this painting of the interior of Colin St John Wilson's house in Cambridge, Hodgkin has included himself, half-obscured by a vertical black pillar, almost to give a sense of scale, as if it were an architect's drawing. In its blending of colour, shape and scale, to produce a sense of pictorial space, *Grantchester Road* was said by another critic, David Sylvester, to mark a watershed in Hodgkin's career.

The Search for the Real
Post-war figurative art in Britain

Since World War II many artists have chosen to engage with a tradition of figurative painting based on perception. The human figure and the physical and social world have been central concerns in the work of these artists. In this respect their work represents an alternative tradition to the succession of abstract art movements that have predominated from the 1950s onwards. In the immediate post-war years British Art Schools, which were traditionally the centre for teaching based on perception and drawing from the life model, saw great expansion and development. They were dominated by the Slade School of Art and the Royal College of Art, where the tutors included the figurative artists Colin Hayes, Carel Weight, Ruskin Spear, Rodrigo Moynihan and John Minton, whose renewed search for realism in this period was signified by such paintings as Minton's sensitive *Portrait of David Tindle as a Boy* (1952).

William Coldstream, who had been one of the leading figures of the pre-war realist Euston Road School, was appointed Professor at the Slade in 1949. Coldstream had a great respect for tradition and placed emphasis on the close observation and measurement of the subject. He became renowned for his austere and obsessive recording of the nude. 'Once I start painting I am occupied with putting things in the right place.' Coldstream's students included Euan Uglow – whose paintings of studio nudes were, like his, plotted using structural reference points – Michael Andrews, Paula Rego and Victor Willing, as well as Peter de Francia, whose politically engaged art, such as the powerful triptych *A Diary of Our Times* (1974), which represents a political torture scene from the Algerian War, raised the question of an art of the left. De Francia's art offers not so much a 'return to the figure' as a new kind of figuration derived from the European tradition of Fernand Léger, Max Beckmann and the Italian communist Renato Guttuso. Guttuso's Social Realist paintings were shown for the first time in London in 1950 and were acclaimed by the Marxist critic John Berger, who saw realism as an ideological force for social change that was opposed to abstraction, insisting 'Realism is not a manner but an approach and an aim.'

Berger also promoted the 'Kitchen Sink' artists John Bratby, Edward Middleditch, Derrick Greaves and Jack Smith, whose uncompromising art was concerned with the commonplace and the clutter of working-class domestic life. The group, who knew each other as students at the Royal College of Art, had provincial origins – Smith and Greaves had grown up on the same street in Sheffield. They were also known as the Beaux Arts Quartet, after the London gallery where they exhibited, which was the leading exhibition space for figurative art in the 1950s, run by the remarkable Helen Lessore, herself an artist. Her late husband, Frederick, was Walter Sickert's brother-in-law. Although Sickert had died in 1942, his artistic legacy was still strong. His engagement with inner-city London had a profound effect on young artists, as did his writings in *A Free House*, which was published in 1948. Sickert's use of press photographs as source material for late works, such as *Gwen Ffrangçon-Davies as 'The Lady with the Lamp'* (1932–34) , also provided a stimulus for artists such as Michael Andrews and Francis Bacon.

David Bomberg had attended Sickert's life-drawing classes at the Westminster Technical College between 1909 and 1910. A contemporary of Stanley Spencer at the Slade, he had made a major contribution to the Vorticist movement and was later to develop a highly personal approach to painting landscape and the figure, which reached its apogee with his moving *The Last Self-Portrait*. Like Coldstream, he was a highly influential teacher and, in the words of Frank Auerbach, 'probably the most original, stubborn, radical intelligence that was to be found in art schools'. However, Bomberg was regarded with suspicion because he rejected traditional teaching methods, urging his students at the Borough Polytechnic to aim not for accuracy or finish but to search for what he called 'the spirit in the mass'. His students included Dennis Creffield, Cliff Holden, Leslie Marr, Dorothy Mead and Dinora Mendelsohn, who exhibited together as the 'Borough Group' (1947–50) and the 'Borough Bottega' (1953–56). Auerbach and Leon Kossoff also attended Bomberg's evening classes while studying at St Martin's School of Art and at the Royal College of Art. Although their work is markedly different, there is a strong resemblance in their 'attack', in which the heavily impastoed paint retains a reality of its own independent of the subject depicted.

Auerbach and Kossoff have frequently been grouped with Andrews, Bacon and Lucian Freud, to form what has been dubbed by R. B. Kitaj as the 'School of London'. Its centre was Muriel Belcher's infamous Soho drinking club, the Colony Room, so memorably celebrated in Andrews's painting, where the bohemian clientele also included the photographers John Deakin and Bruce Bernard and the painters John Minton, Edward Burra and Keith Vaughan. Whether this grouping has meaning beyond friendships and loyalties might be questioned. While their art has been seen to deal with existential concerns, the characteristic these artists undeniably share is their preoccupation with the figure together with an intensely subjective individuality.

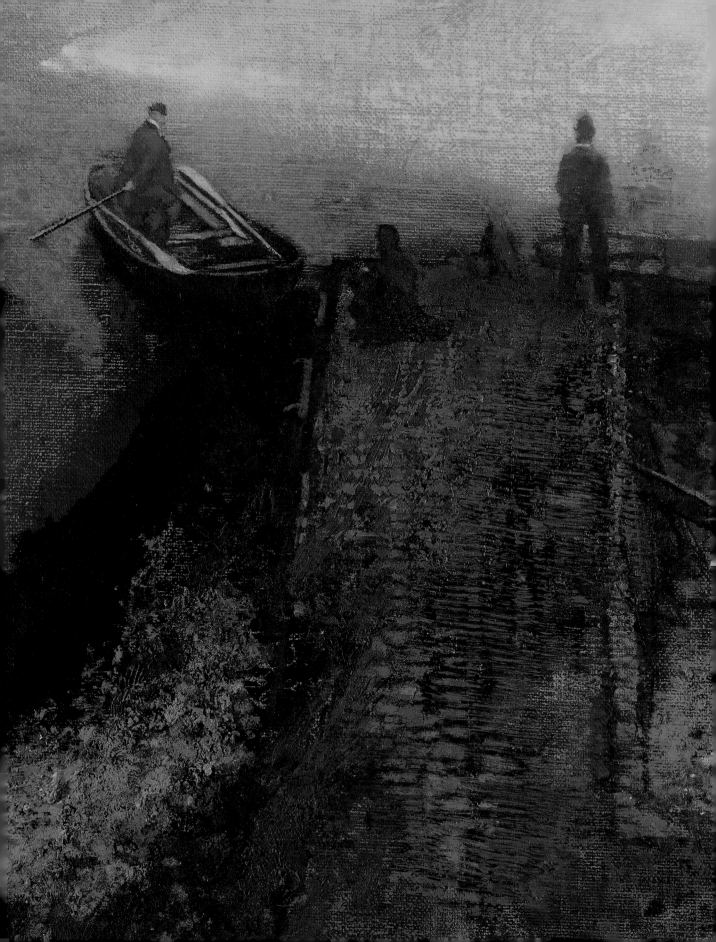

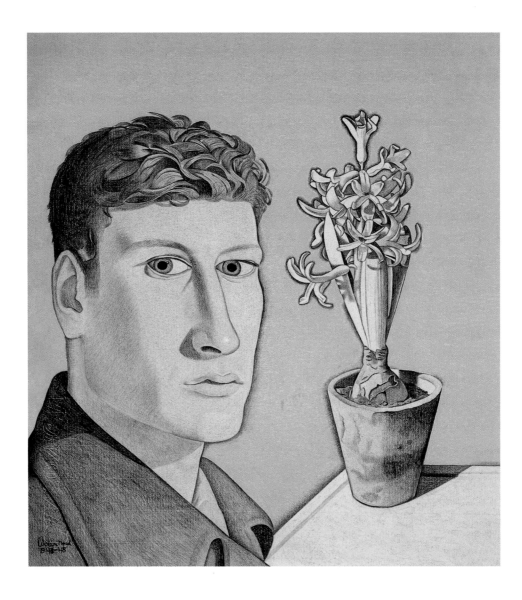

Lucian Freud (1922–)
Self-Portrait with Hyacinth in Pot
(1947–48)

Black, white and yellow crayon on paper
44.5 x 41.3 cm
Wilson Gift, through the National Art
Collections Fund (2004)

The disquieting juxtaposition of this arresting self-portrait with its alienated stare and the beautifully rendered, blossoming hyacinth combines Freud's early interest in the possibilities of Surrealist juxtaposition with a Neo-Romantic interest in plant forms. The exquisite draftsmanship and smooth, sharply focused manner lends intensity to the image, justifying Herbert Read's description of Freud as 'the Ingres of Existentialism'. His eyes look out of the picture but never meet those of the spectator, expressing the 'condition of private loneliness' that Lawrence Gowing identified in Freud's work.

Freud was born in Berlin, the son of the architect Ernst Freud and grandson of the psychoanalyst Sigmund Freud. He came to Britain as a child with his family in 1932. From 1938 to 1939 he attended the Central School of Arts and Crafts, and he subsequently studied under Cedric Morris and Arthur Lett-Haines at their East Anglian School of Painting and Drawing, where pupils were encouraged to let feelings prevail over objective observation. At the end of the 1950s, Freud changed his style from the linear, magic-realist approach of works such as this to a more objective painting style with a heightened sensuality and boldness that has led him to be celebrated for his uncompromising treatment of human flesh.

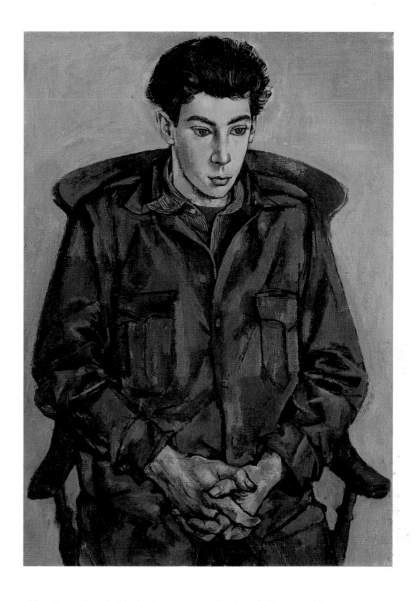

John Minton (1917–57)
David Tindle as a Boy (1952)

Oil on canvas
35.8 x 25.4 cm
Hussey Bequest, Chichester District
Council (1985)

Although notorious for his drunken hedonism in Soho in the 1940s and early 1950s, Minton was also prone to inner melancholy. This poignant half-length portrait, of the artist David Tindle aged 20, seems to be imbued with a sense of Minton's sombre introspection. He once claimed: 'There is no more revealing personality than the visual artist, for a man will paint only of himself and of the things he knows, loves, hates, desires.'

Minton was a tutor at the Royal College of Art in 1951, when he met the young David Tindle at a Sketch Club criticism at St Martin's School of Art. At

that time Tindle was working as a commercial artist in Soho and living in a room on Portobello Road, where Minton produced a drawing of him in April 1952, which is also in the Gallery's collection. This sensitive portrait, which was produced shortly after the drawing, is painted in a very deliberate manner and delicately shaded in muted tones, reflecting Minton's appreciation of Picasso's 'Blue Period'. It also illustrates Minton's move away from the stylization associated with the group of artists that have been loosely termed Neo-Romantic to a more direct form of realism.

David Bomberg (1890–1957)
Tajo and Rocks, Ronda (The Last Landscape) (1956)

Oil on canvas
71.0 x 91.5 cm
Wilson Loan (2004)

In 1954 Bomberg and his wife, the artist Lilian Holt, returned to the Andalucian town of Ronda, set high in southern Spain, where he had painted many canvases 20 years earlier. Bomberg was increasingly infirm but still determined to make images of great power. Journeying by donkey in the valley of the River Tajo, he and Lilian set up their easels about a mile from the rock face.

This painting has a dream-like quality; the surging mass of rock seems to be melting into the light, as rock and sky are woven together in a haze of expressive and chromatically rich brushstrokes. The loosely handled paint conveys a sense of transience, reflecting Bomberg's own state of mind. Reminiscent of the images of Mont Sainte-Victoire by Paul Cézanne, whom he had admired ever since seeing his work in the 1910 'Manet and the Post-Impressionists' exhibition, *Tajo and Rocks, Ronda* was Bomberg's last landscape. It was described by the art historian Richard Cork as having an 'almost visionary exaltation'. Indeed, it could be argued that here Bomberg succeeded in his search to convey what he described as 'the spirit in the mass'.

David Bomberg (1890–1957)
The Last Self-Portrait (1956)

Oil on canvas
76 x 63.5 cm
Wilson Gift, through the National Art
Collections Fund (2004)

Like a final testament, Bomberg's intensely moving *Last Self-Portrait* is filled with a tragic awareness of his impending mortality. His wife Lilian described it as a 'prophetic picture [...] he knew that this was the last portrait and that he was going to die'. Bomberg didn't use a mirror, as he made no attempt to provide a literal likeness. It reveals instead his state of mind, asserting with painful honesty his belief in 'the power of individual vision'.

Bomberg's head is partly obscured by his blue and pink silk scarf, his white painting coat is like a shroud over his emaciated body, and he grasps the palette and brushes of his profession, echoing Rembrandt van Rijn's great self-portrait at Kenwood House, London. This is not a depressing image, however, for it is suffused with radiant light. In the words of the art historian Richard Cork, 'the frailty of the image testifies to the fact that he has barely managed to paint it at all, and therein lies its particular power [...]. Wavering on the edge of extinction, and yet stubborn enough to find a consoling resilience in the near-disembodied image he has created here, Bomberg could hardly have brought his career as a painter to a more memorable close.'

Frank Auerbach (1931–)
Oxford Street Building Site (*c.*1959–61)

Oil on board
55 x 40 cm
Wilson Loan (2004)

Auerbach attended David Bomberg's drawing classes while studying at St Martin's School of Art and the Royal College of Art. This urban landscape is in the expressionist vein of Bomberg's late paintings, proffering not a window on the world but a world brought close. As with all his landscapes, this was painted in the artist's studio, based on sketches made at the location.

During the late 1950s, Auerbach was drawn to the craters of Oxford Street and the Shell building on the banks of the Thames, and he produced a series of paintings based on building sites, which have been seen to reflect his fascination with the destruction he had seen as a child. These have the foreshortened quality of theatrical scenery, providing a link between his interest in theatre and Giovanni Battista Piranesi's architectural fantasies, which, Auerbach has recalled, Bomberg had shown him 'quite early on'.

There is no sky, and space is flattened by the thickness of paint. Auerbach makes space with colour, concentrating on a palette of ochres and earth colours that evoke a sense of excavated ground. The painted surface is incised with tracks that represent the complex structures formed by cranes and scaffolding, which were of great interest to Auerbach.

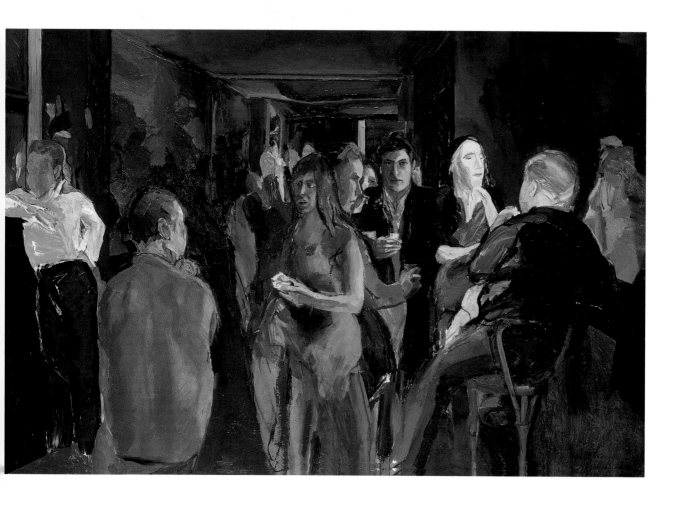

Michael Andrews (1928–95)
The Colony Room I (1962)

Oil on board
120 x 182.8 cm
Wilson Gift, through the National Art
Collections Fund (2004)

From 1954 Andrews frequented the
Colony Room, Muriel Belcher's
celebrated drinking club in Soho. In the
tradition of the conversation piece, this
celebrated painting focuses on the
complex social interaction of a group of
friends. For Andrews, parties and social
groupings were an opportunity to
observe people who are 'together on the
whole by choice – to see each other and/
or to be seen. They allow themselves to
be and are judged. They perform […]. So
as a dramatic or theatrical device it's very
exciting.' It was painted from memory in
his flat in Duncan Terrace, where he
sought to 'adjust and focus my concept
at every signal of recollection'.

From left to right are: the writer
Jeffrey Bernard; the photographer
John Deakin (looking inward); the model
Henrietta Moraes (in the centre); the
photographer Bruce Bernard (behind
Henrietta Moraes and looking right);
Lucian Freud (the furthest back of those
whose faces are visible, engaging the
painter's eye); Carmel (friend of Muriel
Belcher); Francis Bacon (looking inward);
and Muriel Belcher (her gaze met by
Carmel). Four years earlier Andrews had
decorated the Colony Room – his mural,
copied from a painting by Pierre
Bonnard, can be seen on the wall
behind the group.

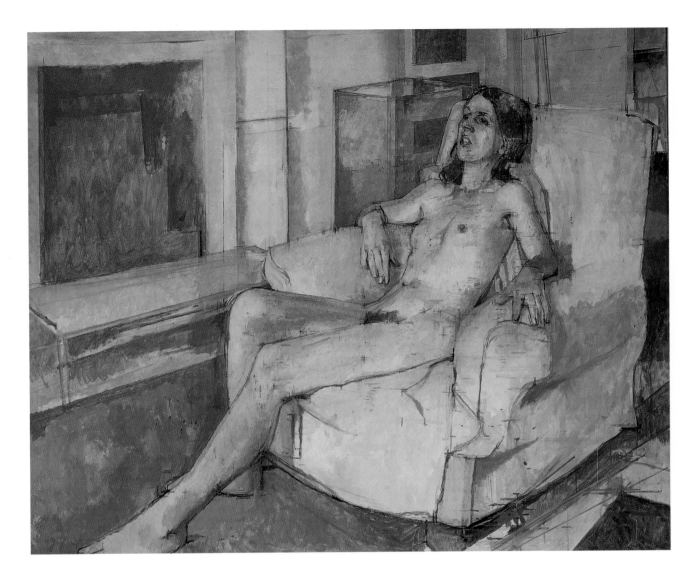

William Coldstream (1908–87)
Seated Nude (1973–74)

Oil on canvas
101.5 x 127 cm
Wilson Loan (2004)

Painted in the living room of the artist and writer Adrian Stokes, *Seated Nude* was likened by the critic David Sylvester to 'a Danae whose shower of gold has not been painted in'. It bears the hallmarks of Coldstream's style – a series of small marks plotting the measured relationships, sightings taken with the brush handle, like a scaffold on which the painting is constructed. His painting technique is based on close observation and an obsession with exactness. When asked why he did not remove the surprising bulky box of a radiogram beside the model, he replied, 'I just thought: what an extraordinary thing to paint this radiogram: and what on earth am I doing painting a radiogram behind a lady with her clothes off at nine o'clock in the morning? So I thought – there it is, that's the situation: we go on.'

Coldstream was a leading figure of the Euston Road School before the war, producing a lyrical realism that took subjects direct from life. As Professor of the Slade School of Art (1949–75) he was enormously influential. The Coldstream Report of 1960 helped to change the structure of art-school teaching in Britain, introducing the compulsory teaching of art history.

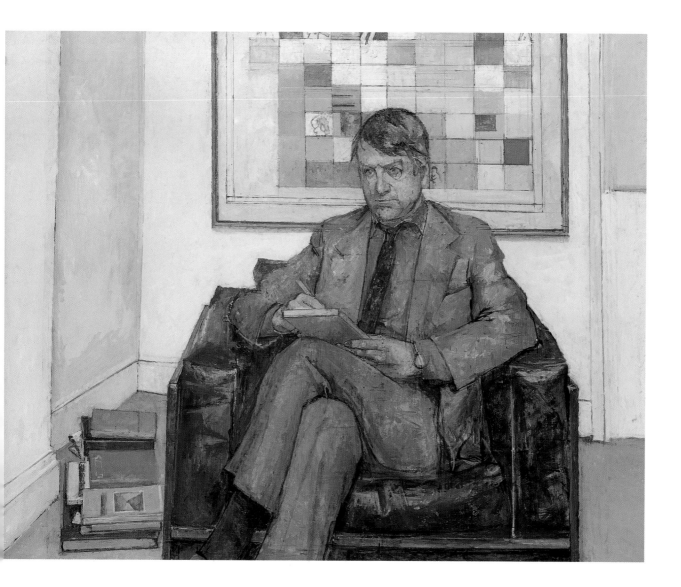

William Coldstream (1908–87)
Portrait of Colin St John Wilson
(1981–83)

Oil on canvas
110.6 x 127 cm
Wilson Loan (2004)

Colin St John Wilson has sat for portraits by a number of British artists, including Michael Andrews, William Coldstream and R. B. Kitaj, and he has written a compelling account of the working methods of Andrews and Coldstream, entitled *The Artist at Work*. This portrait was conceived as a partner piece to Coldstream's *Seated Nude* and painted at Northampton Lodge, Canonbury Square, which was Wilson's office while he worked as architect of the British Library. Wilson is depicted before R. B. Kitaj's painting *Specimen Musings of a Democrat*, the placing of which he has described as an 'impertinence [...] in the fond belief that the grid-lines would help Coldstream to get a move on'. As it was,

there were 96 sittings, twice a week between 9 and 11 am. Wilson is reading Adrian Stokes's book *Colour and Form*, which was also important to Coldstream, and beside him is a small pile of books, introduced for 'iconographical' reasons after the seventieth sitting, which the artist 'simply accepted with complete sang-froid; once the books were there they had to be dealt with like anything else'. These books (*Ulysses*, *The Waste Land*, *Vers une Architecture*, *Tractatus Logico-Philosophicus*, *Charmes* and *Duino Elegies*) were all published within a year of Wilson's birth in 1922, which was also the year in which both Le Corbusier and Aalto set up their architecture practices.

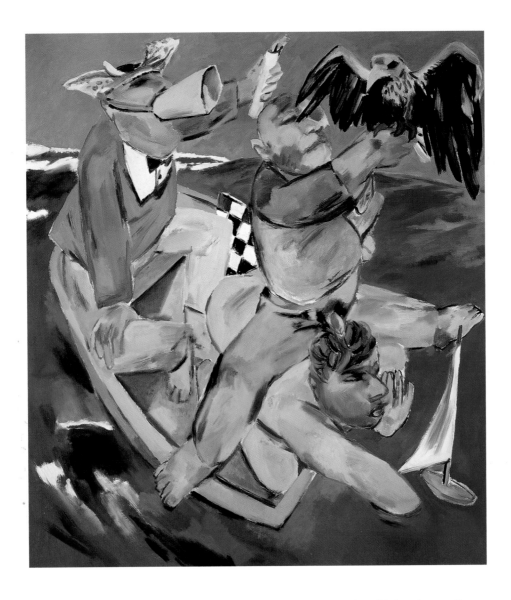

Peter de Francia (1921–)
The Ship of Fools (*c.*1972)

Oil on canvas
178 x 152 cm
Wilson Gift, through the National Art
Collections Fund (2004)

De Francia was born in France to a Franco-Italian father and an English mother. He attended l'Académie Royal des Beaux Arts in Brussels and, after army service during World War II, studied at the Slade School. From 1973 until 1986 de Francia was Professor of Painting at the Royal College of Art.

Much of de Francia's art is concerned with social commentary and political protest. His highly individual style is rooted in the European figurative tradition of Pablo Picasso, Fernand Léger, the Expressionists Max Beckmann and George Grosz, and the Italian Social Realist painter Renato Guttuso, with whom he worked in Rome in the late 1940s. His work is based on sensitive draughtsmanship and a subtle line, as in his charcoal series entitled 'Disparates' (a title borrowed from Goya), which were satirical denunciations of the follies of contemporary society. Like the 'Disparates', *The Ship of Fools* makes reference to the art of the past – a painting by the Netherlandish artist Hieronymous Bosch, which was based on a poem by the fifteenth-century German writer Sebastian Brant, in which the whole of mankind is voyaging through the seas of time on a ship that represents humanity, while each person is a fool.

Victor Willing (1928–88)

Night (1978)

Oil on canvas
228 x 315 cm
Wilson Gift, through the National Art
Collections Fund (2004)

Willing thought of *Night* as his most Baroque painting; he explained: 'There's a wind blowing through, which is something baroque painters were interested in. The boat is foundering.' It relates to the second part of the Book of Jonah, which he had recently read. His art has a visionary quality that derives from the 'revelations' he experienced as a result of suffering from multiple sclerosis. 'I imagined that I was on a sailing boat, alone and at night. The boat was rushing along in a high wind but the sea was turgid, red and visceral with serpentine creatures writhing on the surface. It was very dark – the darkness pressing in claustrophobically […] it was a problem – how to represent it, since the boat's structure and rigging were around me.'

Both Willing and his wife, the artist Paula Rego, were interested in the role of the subconscious in art and underwent Jungian analysis. 'In Jungian imagery the sea represents the unconscious, and so does a basement,' he explained. 'If you put a boat in a basement, you're obviously in pretty deep. And then to have a boat which is out of control tells us that this basement is a stormy place.'

John Davies (1946–)
Small Head No.17 (1978)

Plaster
10.5 x 5.5 x 7.5 cm
Hussey Bequest, Chichester District
Council (1985)

Davies began making body and head casts in plaster in the late 1960s, when he was a student at the Slade School of Art. His bleak figures, like those in Samuel Beckett's existential plays, can be seen as powerful symbols of humanity. In 1977 he wrote: 'I strive to make the figures display the qualities of human beings, rather than those of sculpture.'

At first sight these explorations of the human form appear to be highly realistic, with their finely delineated features and glass eyes. However, the total effect is deliberately unreal: they are at once highly immediate and distant, like robotized humans. Reminiscent of Egyptian funerary masks, they have strong presence, yet, with their pallor and mantle of grey, they appear to belong to another realm, like a vision of tragic humanity. In the words of the art critic Timothy Hyman, 'The effect is as though we've been made to dream them, figures seen through rain or tears, and to take on their burden of grief.'

Frank Auerbach (1931–)
Reclining Head of Gerda Boehm (1982)

Oil on canvas
41.5 x 50 cm
Hussey Bequest, Chichester District
Council (2004)

The art critic David Sylvester once described Auerbach's paintings as, 'morbidly tactile', suggesting that they provide 'a sensation curiously like that of running our fingertips over the contours of a head near us in the dark, reassured by its presence, disturbed by its otherness, doubting what it is, whether it is'. Auerbach seeks to capture the essence of his sitter, endlessly reworking a painting in his search for a true likeness. His pictures are characterized by extremely heavy impasto and a sense of corporeal reality, which creates a tension between the reality of the thing depicted and the reality of the paint.

The author Stephen Spender characterized the figures in his paintings as 'people who seem burdened with perhaps terrible experience […] like refugees conscious of concentration camps'. Auerbach was sent to England in 1939 at the age of seven as a refugee from Nazi Germany, never to see his family again. The model for this picture, Gerda Boehm, was Auerbach's elderly cousin, his only surviving relative in this country, with whom he would stay during his holidays from boarding school. Auerbach always uses models that he knows well and is famous for his 'fidelity to his models'.

The sketch contains the following handwritten notes:

grassy / extend to side of canvas

Shorten to first figures

SAND

Relocate / fisher figures?

The Boat (4 men) standing off

let this / decay / at 2nd. varnish / track

varnish track / let it border sand?

Bring the / water in?

OR BRING IT / RIGHT THROUGH?

lugworm digger?

Michael Andrews (1928–95)
Study for *Thames Painting: The Estuary
(Mouth of the Thames)* (c. 1993)

Ink on paper (sketchbook)
27 x 42 cm

Michael Andrews (1928–95)
*Thames Painting: The Estuary (Mouth
of the Thames)* (1994–95)

Oil and mixed media on canvas
219.8 x 189.1 cm
Wilson Gift, through the National Art
Collections Fund (2004)

Described as an 'elegy to dissolution ' by the art critic William Feaver, *The Estuary* was the last painting on which Andrews worked while undergoing treatment for cancer. The subject was close to his heart because of its relationship to William Mallord Turner's studies on the same theme and for its recurrence in the work of his favourite author, Charles Dickens. On a trip to Canvey Island in Essex, Andrews made sketches, notes and photographs of lugworm diggers and men fishing. These figures and another group (from a photograph of late Victorians standing at the end of a jetty on the Thames) are positioned as intermediaries looking out to sea, giving scale to the painting.

The Estuary combines a sense of aerial perspective with illusionistic distance. The evocative atmosphere changes according to the angle of viewing, as the light falls on a range of textures and washes. In the words of Colin St John Wilson, 'The juxtaposition of the illusory and the manifestly tangible extends the range of our sensibilities, doubles and redoubles our reading of the work time and again. It is a *tour de force*. I know of no other painting that fuses together such competing extremes of figuration and abstraction, illusionism and bald facticity.'

An Open End
Contemporary art

Walter Hussey believed that it is possible to hang a painting of any style or period next to a piece of furniture from any era in a room of any age, as long as each item was of good quality. It is this ethos that led to the creation of Pallant House Gallery and one that still informs its activities in relation to artists and acquisitions. The Gallery deliberately seeks out artists who not only make a powerful statement within contemporary art but are also able to address their concerns within the context of a period house and a modern and historic collection.

The Gallery is very fortunate to be the recipient of an on-going donation of funds to allow the purchase of works on paper by contemporary Scottish artists. The nature of this relationship is particularly special as the donors, Mark Golder and Brian Thompson, allow the Gallery a close involvement in selecting the works to be acquired. This has led to the purchase of prints from, among others, John Bellany, Elizabeth Blackadder, Alan Davie, Peter Howson, Bruce McLean and Adrian Wisziniewski. In addition, many artists have generously donated works to the Gallery; for example, 18 of the artists represented in the Wilson Collection donated unique miniature works for display in *Pallant House Gallery Model 2000*.

When the prospect of an exhibition of prints entitled 'Art for All: From Sickert to the Sixties' coincided with discussions about raising money for the Pallant House Gallery Appeal, the concept of 'Art for All' multiples was born. These specially commissioned editions by key artists in the collection, or those working with the Gallery, would be sold at affordable prices. *Babe Rainbow* by Peter Blake was produced in 1968 in an edition of 10,000 and sold for around £1, becoming an icon of its time, and was a key work in the 'Art for All' exhibition. With 'Babe' in mind, the Gallery approached Blake with the idea of creating a new piece of accessible art and, over lunch, *Bobbie Rainbow* was born. On sale at £30, 'Bobbie' was roughly the price equivalent of 'Babe' in the 1960s but was produced in an edition of 2000, each signed and numbered. Needless to say, *Bobbie Rainbow* was a huge success, with most copies sold to people who had never dreamt they would be able to own a signed Blake.

The success of this project led to the creation of *Frozen Sky* by Langlands & Bell, a piece that takes the form of a wristwatch, the hands of which traverse a moving dial of the coded names of 25 international airports. The watch has been worn by the artists on their travels around the world (and has been sold across Europe), thereby making its significance as a comment on the language of places and its relationship to time all the more relevant.

Wendy Ramshaw and Miranda Watkins were the first artists to participate in a series of residencies supported by Arts Council England South East. In 1999 they embarked on a process of changing the displays in the house with flowers, eggs and other objects. Wendy Ramshaw designed and made a very fine necklace inspired by a Ben Nicholson painting and proposed new gates for the house inspired by a Paul Klee watercolour, both works from the collection. Joy Gregory shared her skills with a multitude of community groups and produced a series of photographs inspired by the 1526 Amberley Panels, 'Heroines of Antiquity', by Lambert Barnard Following the tradition of wall decorations surrounding late seventeenth- and eighteenth-century grand staircases, Paul Huxley created a large-scale wall drawing for the staircase, a temporary piece, that will be followed by other similar commissions in the future. In each residency the artists took a new step in their own development while reacting to Pallant House and its history, the collections and the people who visit and work in the Gallery.

In 2002 the Gallery initiated a unique project called 'Strange Partners' with the National Trust at Petworth House, the Sussex Downs Conservation Board, two local authorities, Arts Council England South East and three estates. The aim was to site contemporary art practice within historic locations, and the result was a group of innovative and widely acclaimed works. *Chalk Stones* on the South Downs, *Moonlit Path* in Petworth Park and *Hearth Stones* at Pallant House Gallery were created by Andy Goldsworthy. Langlands & Bell made installations for Petworth House, including the studio where Turner had once worked, and also created a new work for Pallant House Gallery – *The Ministry (Health and Education)*, an artwork in the form of a carpet, tailored to the dimensions of a room in the Gallery. 'Strange Partners' demonstrated the benefits of working in partnership, and projects such as this will continue to be initiated by the Gallery in years to come.

Wendy Ramshaw (1939–) and
Miranda Watkins (1967–)
View of installation with eggs (1999)

Commissioned by Pallant House Gallery,
through the Arts Council England South
East 'Making Art Matter' scheme

In the first in a series of artists'
residencies, designed to use Pallant
House and the collections as the
starting point for new work, the
jewellers Wendy Ramshaw and Miranda
Watkins transformed the interior of the
Gallery with four elaborate installations.
The work was a direct response to the
building, providing evidence of its
domestic past and presenting semi-
surreal, site-specific displays relating to
everyday life, which incorporated eggs,
fruit and vegetables, flowers and cakes.
Whilst Ramshaw approached the
residency as an opportunity to work in a
completely fresh and different manner,

Watkins saw it as an extension of her
own work.

The first installation featured eggs,
and, in the Easter tradition, Ramshaw
decorated hundreds of eggs in shades
of blue and red, placing them in groups
in unexpected areas of the house.
Watkins considered how to present a
single egg and created a variety of
different holders that were sculptural in
form and unhindered by the need to be
utilitarian. Ramshaw explained: 'We've
used this opportunity to make work that
is light-hearted and amusing. It
encourages people to look at things in a
different way.'

cassandra cursed by apollo with true prophecies never believed

Joy Gregory (1959–)
Cassandra from the series 'Heroines of Antiquity' (1999–2000)

Photograph on board
63.4 x 50 cm
Commissioned by Pallant House Gallery, through the Arts Council England South East 'Making Art Matter' scheme

Joy Gregory is an artist and educator whose work has frequently focused on issues of identity through explorations of race, gender and sexuality. In 1999 she was artist in residence at Pallant House Gallery, through the 'Making Art Matter' scheme. Gregory chose to create contemporary responses to the sixteenth-century 'Heroines of Antiquity' by Lambert Barnard, photographing female friends and staff at the Gallery as the extraordinary proto-feminists of the original series – women who were not only known as empire builders, but who were also seen to personify great courage and virtue in the face of adversity. 'History is the story we tell

ourselves to define and outline an identity,' Gregory has said. 'These stories need not be totally true, but must be believable. They are the stories which tell us who we are, what we are, where we are and how we are.'

Cassandra was the daughter of King Priam of Troy. She was pursued by Apollo, who gave her second sight, but when she spurned his amorous advances he doomed her to see the future clearly, but never to have her prophecies believed. During the siege of Troy she predicted the Greek invasion of the city via the Trojan Horse and recognized Paris as the destroyer of the city.

Paul Huxley (1938–)
Wall Drawing (2001)

Household paint
Commissioned by Pallant House Gallery, through the Arts Council England South East 'Making Art Matter' scheme

During his 2001 residency, Huxley produced designs for the area that surrounds the grand staircase in Pallant House. These were installed *in situ*, once the design had evolved further in a temporary studio at the Gallery. The project represented a special challenge for the artist, former Professor of Painting at the Royal College of Art, who usually works on canvas or paper. Huxley reinterpreted the tradition of mural painting that is sometimes seen in eighteenth-century country houses. Wishing to avoid the word 'mural' and its associations with integral, permanent, illusionary vistas, Huxley called the work *Wall Drawing*. He

explained: 'I do not expect it to be permanent and although I want it to be surprising and diverting it will not be escapism. Its subject is its own location […]. Those who know my work will recognise something of my vocabulary of bold geometry. For others this may seem a radical intervention on a familiar and comfortable building. But I want the piece to be fitting. The main colour is one traditionally used in Georgian buildings and the geometry, however eccentric it may seem, is an extension of the measurements and details found in the hallway and landings of the house.'

Peter Blake (1932–)
Bobbie Rainbow (2001)

Lithoprint on tin
66 x 44 cm
Pallant House Gallery (2002)

In 1968 Peter Blake produced a screenprint on tin in an edition of 10,000, commissioned by a sign-making company in the wake of the phenomenal success of the cover for *Sgt Pepper's Lonely Hearts Club Band* by The Beatles. The subject was Babe Rainbow, one in a stable of circus-performers, freaks and wrestlers invented by Blake for his art works. In 2001, as the first of the series of 'Art for All' multiples commissioned by Pallant House Gallery, Blake created a contemporary riposte to Babe.

'Bobbie Rainbow is the daughter of Babe Rainbow, a fictitious lady wrestler, who in turn was the daughter of the infamous Doktor K. Tortur. Bobbie's father is unknown, but she was born during 1976, when Babe was living and wrestling in New York (for a brief period in 1973 she was the world champion), and her most likely father is Ebony Superman, who was also world champion at that time. Bobbie is wearing the championship belts and famous leather hat passed on to her by Babe, when she retired from the ring in 1989. She is currently wrestling in the USA and around the world. Bobbie bears an uncanny resemblance to her mother.' (Peter Blake, 22 September 2001, London)

Various artists
Pallant House Gallery Model 2000

Various media
56 x 110.8 x 38.2 cm
Wilson Gift, through the National Art
Collections Fund (2004)

Pictured from left to right: Anthony
Caro's *Sculpture Three*; Joe Tilson's *9
Elements*; Patrick Caulfield's *Pipe on
Table*; William Tucker's *Study for
Leonidas*; Paul Huxley's *After Mutatis
Mutandis I*; and Peter Blake's *Tuesday*

In 2000 Pallant House Gallery
commissioned a model art gallery
based on the plans of two galleries for
the new wing and containing works by
the artists represented in Colin St John
Wilson's collection. Colin Cunningham's
architectural model includes unique
miniature artworks by Frank Auerbach,
Peter Blake, Anthony Caro, Patrick
Caulfield, Prunella Clough, Dennis
Creffield, Rita Donagh, Peter de Francia,
Antony Gormley, Howard Hodgkin, R. B.
Kitaj, Mark Lancaster, Dhruva Mistry,
Eduardo Paolozzi, Tom Phillips, Joe Tilson
and William Tucker. The artists involved
took the challenge set them very
seriously. Frank Auerbach commented,
'a tiny painting is as difficult as a huge

one,' while Patrick Caulfield emphasized
the complexities of painting miniatures,
saying, 'This image is more of a small
painting than a miniature large one.'

It is a contemporary equivalent of
a model modern art gallery from 1934
that is in the Gallery's collection. The
model and the artworks were kept as
a surprise for Professor Wilson and
unveiled at the Royal Academy in the
company of many of its creators,
serving as a fitting tribute to the
strength of the relationship between
collector and artists. It went on to win
the *Architects' Journal* Bovis Lend
Lease Grand Award at the Royal
Academy Summer Exhibition in 2000.

Langlands & Bell
(Ben Langlands (1955–)
and Nikki Bell (1959–))
The Ministry (Health and Education)
(2002)

Brussels weave carpet
340 x 340 cm
Pallant House Gallery, with assistance
from the Friends of Pallant House, the
National Art Collections Fund and the
V&A Purchase Grant Fund

Langlands & Bell examine our experience of architecture and urban culture at many different levels, exploring the places and structures we inhabit and the routes that penetrate and link them. *The Ministry* is based on a photograph of the iconic Ministry of Health and Education in Rio de Janeiro, which was designed by the architects Lúcio Costa, Oscar Niemeyer and Le Corbusier. In the words of the artists: 'Making a work like "The Ministry", which "represents" the façade of a building on the floor through the medium of a woven carpet, which is usually a utilitarian object, is another part of the questioning of the relationship between

the object, the subject, and the image in art, and to ask where it is that we find them? "The Ministry" is putting the viewer in a new position. It allows you to walk around it and as you do so your relationship to it continually changes. You ask yourself, is it a picture, or is it a carpet? Is it a photo of a building, or is it a geometric design? Is it an optical experience, or a tactile experience? Is it primarily a usable object? Or is it mainly there to contemplate? The answer is that it can be all of them. What it is, is shifting the whole time. It has a multiple focus, yet its purpose is art, and it prompts us to question where we can make or find art in life.'

Andy Goldsworthy (1956–)
Hearth Stones (2002)

Incised chalkstone sculptures
60 x 80 x 60 cm and eight smaller stones
56 x 35.5 x 25.5 cm
Pallant House with the assistance from
the Friends of Pallant House, the
National Art Collections Fund and
Resource/V&A Purchase Grant (2003)

Environmental artist Andy Goldsworthy works mainly in the open air, using those natural materials to hand to create sculptures that become an integral part of the natural environment. Chalk is the mother stone of much of the South Downs surrounding Chichester. The stones had weathered naturally since being excavated from the Downs, and the grey, outer surface was then 'etched' by the artist using flint, which is embedded in the chalkstone, to reveal the white of the chalk beneath. His idea was to bring the outside environment within the walls of the Gallery. In Goldsworthy's words, 'I looked for spaces that had a dialogue with the work [...]. A hearth is the traditional place to gather round in the night. It becomes the focus for dark, cold, winter nights. And the burning of coal has led to the discolouration of stone over the years.'

The designs 'etched' into the stones reflect the artist's understanding of how the countryside was created. Across a natural hillside, man has created rectangles, demarcating territory and altering the way we see the land. Goldsworthy is not criticizing this but rather stressing that the countryside we see and appreciate is made and maintained by man.

Peter Howson (1958–)
Suspicious Boy (1994)

Woodcut on paper
No. 3 of an edition of 50
122 x 92 cm
Golder-Thompson Gift (2001)

In spring 1993, Howson was commissioned by the Imperial War Museum (IWM) to document the conflict in Bosnia. He made two visits, travelling with the British forces participating in the United Nations Protection Force to what was termed 'the cauldron of the war'. The IWM's choice of official war artist had been criticized for being too obvious, since Howson was known for raw, figurative work based on macho subjects drawn from the streets of Glasgow. The artist himself commented that being in Bosnia 'was like walking into one of my own huge paintings. Those hellish visions brought to life.'

Aware too of the dilemma inherent in being awarded an artistic commission that was to be based on human suffering, Howson argued that 'if I can capture something on canvas that conveys the horror of what's going on, I'll be justified in going there'.

In the resulting body of work, Howson frequently depicted events that he himself had not witnessed but that had been recounted to him; or he imagined having seen their bloody aftermath. In particular, Howson used the faces of Muslim, Serb and Croat children to signify the war and its lasting impact.

Index

Numbers in italics refer to illustrations